LITTLE BOOK OF

Schiaparelli

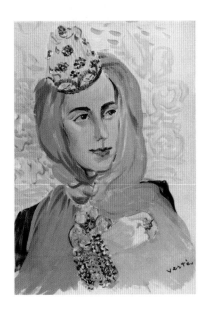

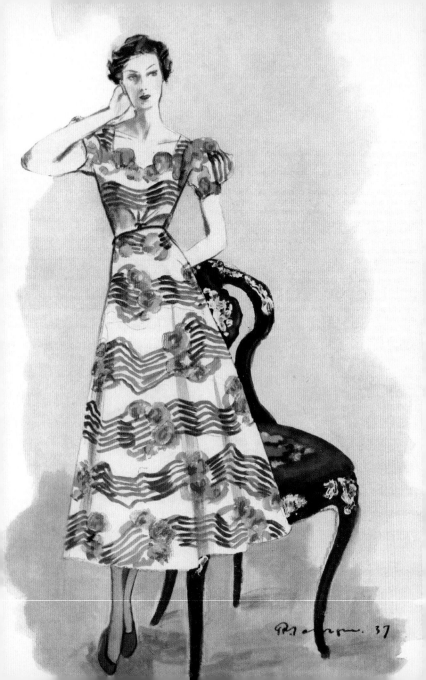

LITTLE BOOK OF

Schiaparelli

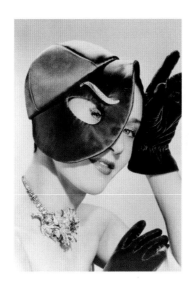

EMMA BAXTER-WRIGHT

WELBECK

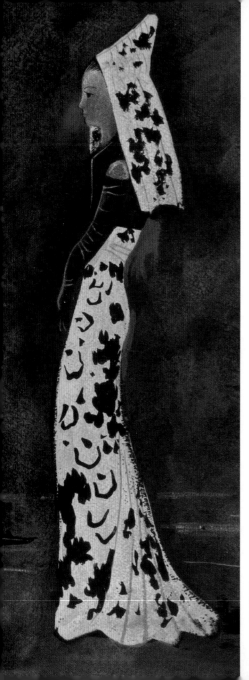

To Dusty the Fashionista

First published by Carlton Books Limited in 2012. This edition published in 2021 by Welbeck, an imprint of Welbeck Non-fiction Limited, part of Welbeck Publishing Group.

Based in London and Sydney.
www.welbeckpublishing.com

Design and layout © Welbeck Non-fiction Limited 2021
Text © 2012, 2020 Emma Baxter-Wright

Emma Baxter-Wright asserts her moral right to be identified as the author of this Work in accordance with the Copyright Designs and Patents Act 1988.

A CIP catalogue record for this book is available from the British Library.

ISBN: 978-1-78739-828-3

Printed in China

Contents

Opposite Black-on-pink printed
evening gown, fitted to the body
and flared from the knee; worn
with full-length, black evening
gloves and a cropped faille bolero.
The turban, shown here unbound,
and the bolero were key pieces
for Schiaparelli.

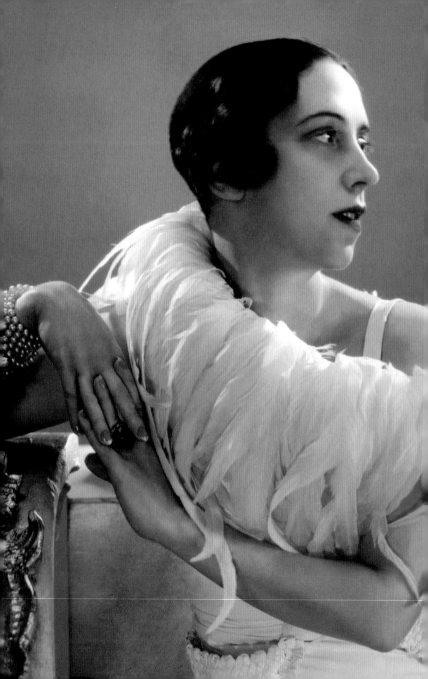

Introduction

When Elsa Schiaparelli arrived on planet fashion, she smashed down the walls of convention and watched the world fall in love with her. In the most brilliantly, dramatic style she set out to challenge our perception of what fashion could be, if only we dared abandon the commonplace and instead allowed her strangely imaginative vision to entertain us. A tiny Italian dynamo with an unspeakably difficult name, she joked that nobody would know how to pronounce it properly S-k-e-e-a-p-a-r-elly – but she *knew* that everybody would understand what the name stood for. A complex hybrid of contradictions – an aristocratic Italian living in Paris, who was hugely influenced by the cultural modernity of 1920s New York – she never ceased to cause a commotion with her inventive spirit. Elsa craved colour, loved laughter and insisted on only two rules in her workroom: that the word "impossible" should be banned and also "creation" – a word she found completely pretentious. Throughout the 1930s Schiaparelli caused a riotous sensation, season after season, with each collection more daring, more ambitious and more memorable than the former. She fell in step with the Surrealists living in Paris and was one of the first couturiers to collaborate with contemporary artists. Visual irony, textural contradictions and elaborate details were frequently employed to question the function of gender in the most defiant style. Yves Saint Laurent famously said Schiaparelli "didn't want to please, she wanted to dominate", and of that there is no question. She was the most innovative of couturiers, disciplined, shy, unpredictable and relentlessly pushing new forms and ideas. The genius forerunner of every modern designer, she found a way to successfully combine eccentricity with functionality, to provoke and shock us in the most beautiful way.

Opposite In this portrait of Schiaparelli, taken in 1932 by leading fashion photographer George Hoyningen-Huene, she is wearing one of her own designs. The white evening dress had quilted pocket details and was worn with a white coq feather boa.

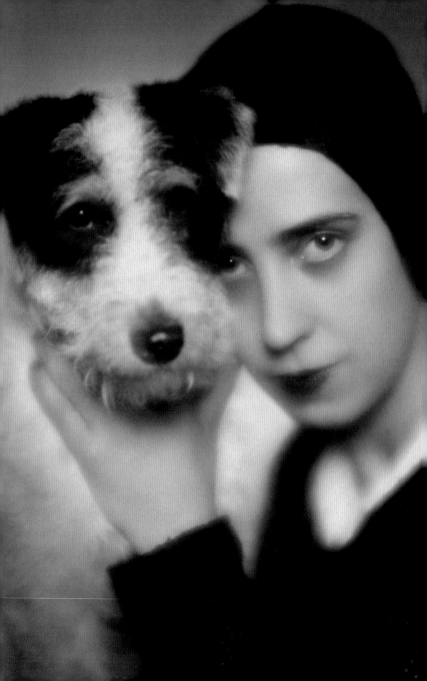

The Early Years

In her autobiography *Shocking Life*, Schiaparelli's own recollection of childhood appears to rollercoaster endlessly between disappointments, the first of which was that she turned out to be a girl when her parents were desperately hoping for a boy, and a constant stream of practical jokes. Born in 1890 at the Palazzo Corsini in Rome, her early life was undoubtedly one of privilege and status. Brought up in a loving and honourable family, the second of two girls, born to an aristocratic Neapolitan mother and an academic father, who was an expert on Oriental Studies and taught at the University of Rome, there was little in her family background to suggest a creative career in haute couture lay ahead.

She claims to have been an ugly-looking child and often felt criticized by her mother, who continually made disparaging comments about her appearance while simultaneously praising her sister for her classical Greek beauty. Allowing her childish imagination free reign, Elsa thought to beautify herself by planting soil and flower seeds all over her face, including in her mouth and ears, believing a beautiful floral face would sprout. On this occasion there was no punishment, just more disappointment that no flowers grew to transform her into a great beauty. At the Convent of the Lucchesi in Rome, she prepared for her first communion in a state of panic, overcome by the mystical atmosphere of ceremonial ritual. Determined to accuse herself of the greatest sins possible, in order to allow herself to be absolved and so transcend to heaven faster, she whispered to the priest, "Yes, Father, I have fornicated," at which point she fell theatrically to the floor in a dead faint. It was the first documented account of many such dramatic entrances that lay ahead.

Opposite Portrait of Elsa with her dog, taken at the start of her career in Vienna, circa 1926.

Elsa's strait-laced family seemed resigned to her acts of lunacy, which played a significant role in family life. Once, after an earthquake had destroyed a large part of Sicily and the country was in mourning, large open trucks trundled slowly through the city, allowing survivors to contribute to a relief fund by simply throwing any items of surplus clothing onto them. Alone at the time, Elsa rushed through the family home gathering up armfuls of clothes and linen, then joyously threw them down from the windows onto the passing lorries, convinced of her own generosity. On another occasion she threw herself out of a window with an umbrella, believing it would act as a parachute. It didn't, but she fell into a heap of manure unscathed! The quirkiness of these childhood anecdotes reveal an early penchant for humour that lay the foundations for the grown-up couturier's desire to endlessly amuse with her creativity.

Elsa's unpredictable behaviour disrupted her formal education as her family moved her to different institutions to maintain an element of control. As a teenager her wildly imaginative poems about love, loss and sorrow were published in a small volume called *Arethusa* and the controversial work, which was considered to be a disgraceful taint on the ultra-conservative Schiaparelli family, resulted in another punishment that saw her packed off to a convent in Switzerland. Angry and unhappy in the hostile environment, Elsa went on hunger strike until her kindly father capitulated and came to collect her home.

To escape the amorous attentions of an ugly Russian suitor, Elsa took a job in London as a nanny, travelling via Paris to attend her first society ball. With nothing appropriate to wear she visited Galeries Lafayette and bought four yards of dark blue crepe de chine and two yards of orange silk, which she wrapped around her and pinned into place. Her outrageous attire caused a small sensation and was noted as the start of many such extraordinary appearances. She called it her "first couturier's

Opposite Theatricality and an element of shock were themes that Schiaparelli often explored in fashion, and she was certainly her own best advertisement for her designs. Here, she wears outrageous fancy dress for a ball given by Jacques Fath at the Château de Courbeville, near Chessy in France, in August 1952.

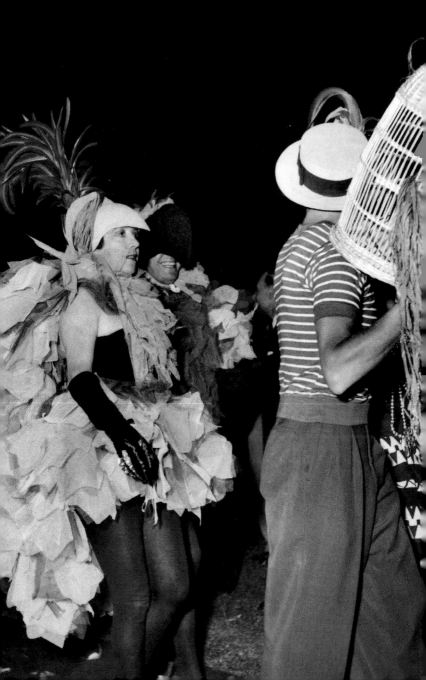

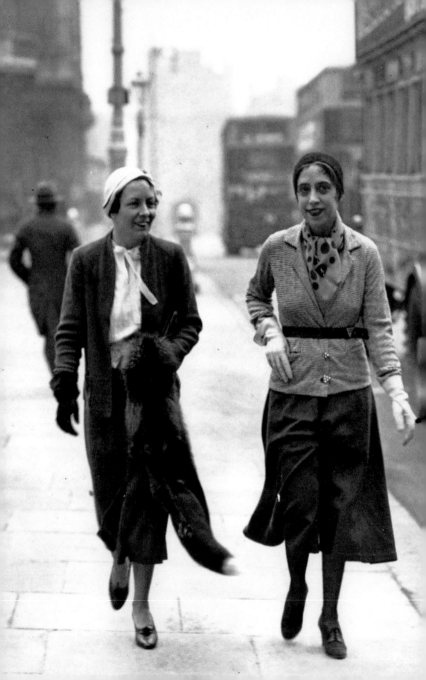

failure". In London, Elsa, who had briefly studied philosophy at the University of Rome, spent her time visiting libraries and attending lectures. At one of these she met a lecturer in theosophy who was half Breton French on his father's side and half Swiss French on his mother's side. He was in his early thirties and his name was Compte William de Wendt de Kerlor. Within 24 hours of meeting each other the couple had decided to get married.

London, New York, Paris

Despite opposition from her family, who rushed to intervene, the wedding took place at a registry office, with little grandeur and no white wedding dress. The year was 1914 and Elsa was 23 years old. On returning from the simple ceremony to the small mews house they were renting, the new Comtesse de Kerlor discovered all seven mirrors in the house had been smashed. The mystery was unresolved, but as Elsa remarked, "it was a sinister beginning". With the First World War imminent, life in London became increasingly impossible for the young European couple, who escaped to a small flat on the seafront in Nice. Precise details of these first few years of married life in the South of France remain unclear, but Elsa's husband became increasingly absent, acting like a "drifting cloud in the sky" and leaving her waiting for days at a time for him to return. Although Elsa writes in her autobiography that she did not want to leave Nice, William wanted to go to America and so in 1919 they arrived in New York City. That year Elsa gave birth to her only child – a girl, named Maria Luisa Yvonne Radha de Wendt de Kerlor, who was quickly nicknamed "Gogo". While Elsa responded immediately to the modernity of New York, her husband – who never felt psychologically strong enough to cope with the pressure of the

Opposite Elsa Schiaparelli (right), walking with a friend in London in 1935. She is wearing culottes of her own design.

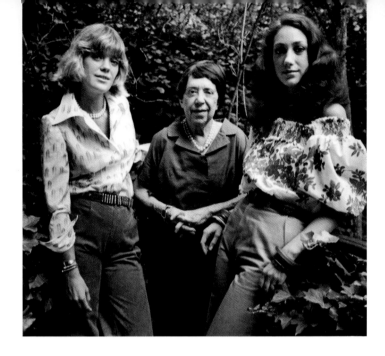

city – succumbed to the charms of many other women, including the dancer Isadora Duncan, and abandoned his family soon after the birth of his daughter. Nearly 30, alone and broke in a foreign city, with a newborn baby to take care of, a proud and independent Elsa almost hit rock bottom. The death of her father at this time, together with the disintegration of her marriage, acted as a catalyst to shape the future direction of Elsa's life. She knew that she would not re-marry and never again would she be dependent on any man to provide for her. The desire to stand alone and live independently ultimately led to the invention of her alter ego "Schiap", who would later find international success as the creator of so many of the avant-garde ideas that still have resonance today.

On the Atlantic crossing from France to America, Elsa and William had met Gabriella Picabia, ex-wife of the French modernist artist Francis Picabia, who together with Man Ray (Emmanuel Radnitzky) were significant contributors to both the Dada and Surrealist art movements. Fortuitously the two were destined to meet again in New York and the older French woman, whom Elsa described as "a woman of great

intelligence and a great heart" not only gave support as a friend but also provided some childcare for Gogo, allowing Elsa time to search for work. More importantly perhaps she also introduced the designer to an interesting circle of artistic friends, which included the photographers Alfred Stieglitz, Baron de Meyer, Edward Steichen, Marcel Duchamp and Man Ray, many of whom were destined through their own artistic practice to have great influence on Schiaparelli.

Living in cramped accommodation in Greenwich Village, a haven for artistic and literary types, Elsa developed a great friendship with another strong woman who was to prove instrumental in shaping her future. Blanche Hayes was a young American woman who had been married to a wealthy lawyer, but was now, like Elsa, seeking a divorce. When Elsa made the shocking discovery that at 15 months Gogo could only "walk like a crab" and was diagnosed with infantile paralysis, it was Blanche who calmly suggested a solution. They were to travel together to Paris, which was much cheaper than New York, where they would stay as her guests and seek medical expertise to help Gogo. They sailed in June 1922, and in Paris Elsa started divorce proceedings against her absent husband and also renewed her passport in her original name of Mlle Schiaparelli.

This trip to Paris was to change her life, as she recalled in 1954: "If I have become what I am, I owe it to two distinct things – poverty and Paris. Poverty forced me to work, and Paris gave me a liking for it."

In Paris, Elsa struggled financially, surviving on small handouts from her mother, and scouring the flea markets and auction houses in

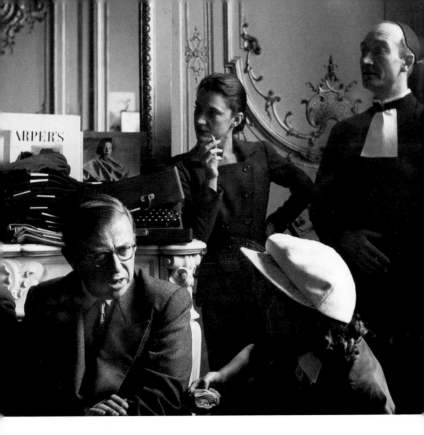

search of beautiful items that could be sold on through sympathetic antique dealers. Her friendship with Gaby Picabia was reignited, which connected her to the Parisian group of artists and poets still operating loosely under the Dada collective. Tristan Tzara, Francis Picabia and Jean Cocteau all congregated at a small den of debauchery called *Le Boeuf sur le Toit,* to which Elsa was introduced by Man Ray. There she found le tout Paris, many of whom would figure prominently in her life. Among them were Pablo Picasso, Nancy Cunard, Gabrielle "Coco" Chanel, Erik Satie, Mrs Reginald (Daisy) Fellowes and the Prince of Wales.

Living alone in two rooms on two floors of the Rue de l'Universite, the hand of fate intervened when Elsa met the French couturier Paul Poiret, a man whom she greatly admired – calling him the "Leonardo of

Fashion". Poiret was revolutionary in his influence on women's fashion, designing successive collections that experimented with silhouette, colour, print and extravagant fabrics. An innovative visionary, he was one of the first fashion designers to collaborate with an artist, working with the young Raoul Dufy, who created printed textiles for Poiret's clothing. Elsa had never before set foot in a *maison de couture* and in her autobiography *Shocking Life* she describes her first meeting with Poiret:

> While my friend was choosing lovely dresses, I gazed around moonstruck.
> Silently I tried things on, and became so enthusiastic that I forgot where I was. I put on a coat of large loose cut that could have been made today. This coat was made of upholstery velvet – black with big vivid stripes, lined with bright blue crepe de chine.
> "Why don't you buy it *mademoiselle*? It might have been made for you."
> The great Poiret himself was looking at me. I felt the impact of our personalities.
> "I cannot buy it," I said. "It is certainly too expensive, and when could I wear it?"
> "Don't worry about money," said Poiret, "and *you* could wear anything anywhere."

So began a great friendship of excellent food, cheap white wine and wonderful conversation. Poiret was terrifically kind to Elsa and gave her a fabulous wardrobe of extravagant clothes to wear. While this generosity enabled her to become a fashion leader, it also lit the fuse to ignite her own passion for creating fashion, something Poiret encouraged.

Launch of "Pour le Sport"

With Gogo safely packed off to a school in Lausanne, Elsa had time yet again to consider her own future. She did not know at this point how her own terrific accumulation of energy would find a way to express itself, although she was starting to think that perhaps instead of painting or sculpture (both of which she was fairly accomplished in), that she could perhaps invent dresses or costumes. Highly creative and even in the early days always conceptual in her thinking, Schiaparelli's approach to dress designing was something she perceived not as a profession but always as an Art. In her recollection she,

> found that it was a most difficult and unsatisfying art, because as soon as a dress is born it has already become a thing of the past. Once you have created it, the dress no longer belongs to you. A dress cannot just hang like a painting on the wall, or like a book remain in tact and live a long and sheltered life.

Fashion had started to change in a radical new direction. Poiret's elaborate grandeur was out of step with post-war women as a new emphasis had been placed on youth, simplicity and a growing appreciation of sporting activities. Gabrielle Chanel capitalized on this youthful spirit, designing specifically for the modern woman, who with her bobbed hair and narrow slim-line body was known as *la Garçonne*. The emphasis on sporty, wearable clothes that allowed a woman to move her body without uncomfortable restriction owed much to Chanel's choice of fabric. She introduced lightweight silk jersey and pioneered the use of machine knits, for dresses, twinsets and sweaters, all in a neutral colour palette. In fact it

Opposite Schiaparelli's early designs were highly influenced by sporting activities. This 1928 knitted two-piece swimsuit, consisting of a black-and-white striped vest and black flannel shorts with side opening, worn with matching striped socks, appealed to a new generation of modern women, as it was both comfortable and practical.

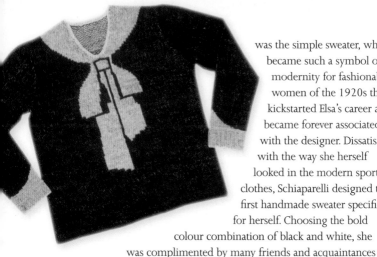

was the simple sweater, which became such a symbol of modernity for fashionable women of the 1920s that kickstarted Elsa's career and became forever associated with the designer. Dissatisfied with the way she herself looked in the modern sports clothes, Schiaparelli designed the first handmade sweater specifically for herself. Choosing the bold colour combination of black and white, she was complimented by many friends and acquaintances when she first wore it. A wealthy friend of Blanche Hayes, a Mrs Hartley, agreed to sponsor Elsa in a small collection of sports clothes, and from a small dress house called Maison Lambal, situated near Place Vendôme, her first collection appeared. These interchangeable separates, of knitted jackets and crepe de chine skirts, received a favourable response from both the public and the press. In January 1926, *Women's Wear Daily* reviewed Maison Lambal's stylish garments: "The collection, although not large, is carefully conceived and executed. Each mode maintains individuality and reveals interest. They are all simple and direct with very fine detail work and pleasing colour combinations."

Although the financial backer backed out at this point, the capsule collections continued with the help of French businessman Monsieur Kahn, who had associations with Galeries Lafayette and Madeleine Vionnet.

Above The famous trompe-l'oeil sweater caused a sensation when Schiaparelli wore it to lunch in 1927. The final version, achieved after several less-successful attempts, was much copied and became one of the most famous designs of Schiaparelli's career.

Opposite Schiaparelli's early collections were heavily based on knitwear and she used it for everything from socks to swimsuits. This winter sports outfit from 1934 includes matching gloves, scarf and Peruvian *chullo*, a traditional hood with long earflaps.

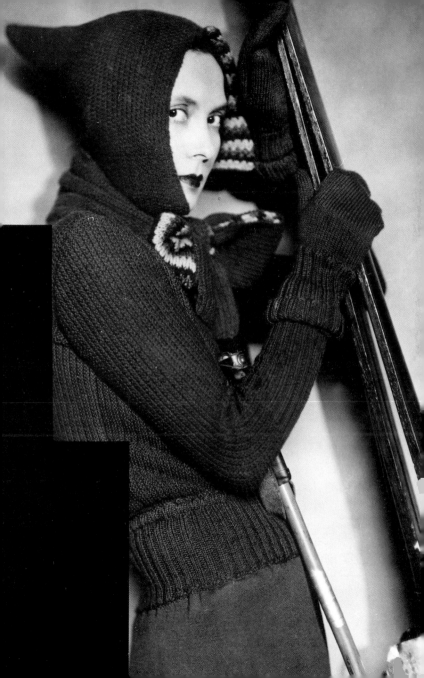

The first few pieces were called Display No. 1 and were laid out on tables, piece by piece, in Schiaparelli's small apartment. Taking design inspiration from Futurism and Cubism, Elsa's aesthetic reflected the stark strong lines and bold patterns and colours of those contemporary art movements. In April 1927 a smart American friend visiting Elsa in Paris wore a sweater that caught the designer's eye. Although much has been made of Elsa's first handmade trompe-l'oeil sweaters, in *Shocking Life* she reveals that she never learnt to knit, and that "the art of clicking two little metal needles together has always been a mystery". The Armenian refugee who had actually made the sweater lived nearby. When approached by the designer and asked to copy her drawings of a simple white butterfly bow tied around the neck of a fitted black sweater she enthusiastically agreed to give it a go. It took three attempts to get right, but the third sweater caused a sensation when Elsa wore it to a grand luncheon. Feminine and decorative, it was very different to the woollen clothes that Chanel was making.

A buyer from the New York store, Strauss, recognized how striking the sweater was and immediately placed an order for 40 sweaters and 40 skirts. Thrilled with the response, Elsa agreed, even though she had absolutely no idea where the skirts would come from and what they would look like. But true to her word, the order was shipped on time and the New York store paid for the work within three weeks. Buoyed up by her success, Elsa wanted bigger premises. She found a small garret at No. 4 rue de la Paix, where she could both live and work, from which her first modest collections of shantung seaside pyjamas, bathing suits, frocks and tailored jackets with geometric patterns were shown. By the end of the decade garments for watching sports in were the strongest influence on fashion and Schiaparelli, inspired by Charles Lindbergh's flight across the Atlantic, designed flying suits for women as well as clothes for skiing and suits for tennis and golf. Her wrap-around skirts first arrived in 1928, as did the divided skirt which caused such a stir at Wimbledon in 1931, when the Spanish player Lili de Alvarez arrived in an outfit that had been specially made for her by Schiaparelli.

All the clothes were simply laid out on tables and it was from these three attic rooms in January 1928 that an official sign appeared above the door on the street. In black and white it simply said – Schiaparelli – and underneath "Pour le Sport".

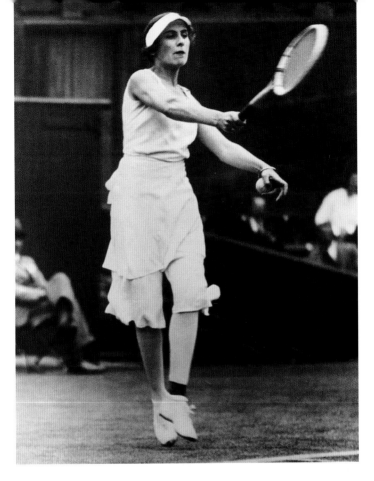

Above The Spanish tennis player
Lili de Alvarez caused uproar
when she appeared at Wimbledon
in 1931 in an ensemble that had
been specially created for her
by Schiaparelli. The divided skirt
(known as "culottes") was another
Schiaparelli invention, designed
with practicality in mind.

Overleaf left Wrap-around skirts
and dresses were a Schiaparelli
innovation, repeated years later
by Diane von Furstenberg. These
beach dresses consisted of four
half-dresses, each with one armhole
and a tie that passed through a slit
on the other side; each side was in
contrasting shades of silk.

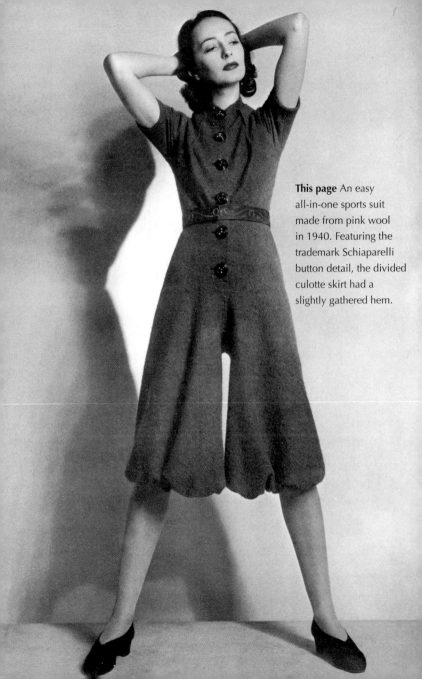

This page An easy all-in-one sports suit made from pink wool in 1940. Featuring the trademark Schiaparelli button detail, the divided culotte skirt had a slightly gathered hem.

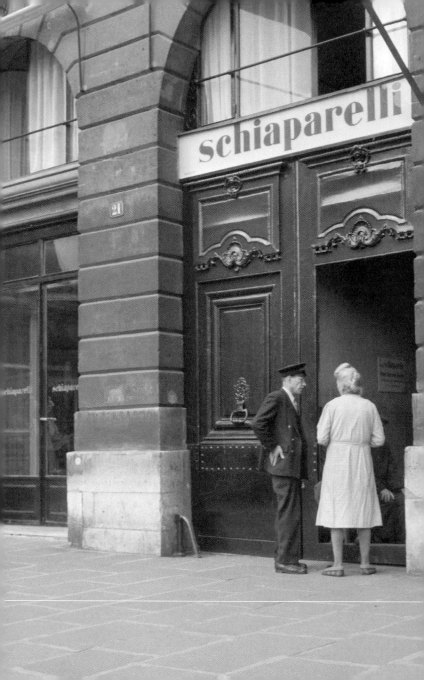

The House of Schiaparelli

*"She slapped Paris. She smacked it. She tortured it.
She bewitched it. And it fell madly in love with her."*

Yves Saint Laurent

Elsa Schiaparelli acknowledged that ignorance and courage were the qualities that drove her early success in rue de la Paix and as the garret became increasingly crowded, her designs became more daring. Speaking of herself in the third person (as she often did in her autobiography), she stated: "Schiap herself did not know anything about dressmaking" and it is this lack of formal training that she used brilliantly to her advantage. From the start she felt that clothes should be constructed architecturally and that the body should be thought of as a frame, as in a building. With this basis she found a way throughout her career to produce clothes that could empower women. She became increasingly experimental with the colours and designs, trompe-l'oeil ties appeared, as did scarves, slung low around the hips and then tied with a real tie at one side. Sometimes she drew African-inspired designs or magical symbols influenced by the tribesman in the French Congo, and tattoos that mimicked a sailor's chest with pierced hearts and snakes. Nothing had ever been seen like the Skeleton sweater, which so shocked the fashion press. Graphically stark, it consisted of a black sweater with white knitted lines resembling the thorax and ribcage, and it gave the women who were brave enough to wear it the appearance of being seen through an X-ray machine. Her knitwear expanded to include the most extraordinary collection of clothes, some of which seem totally at odds with the elasticity of the fabric: sandals, stockings, bathing suits, bonnets and skirts, as well as a knitted turban, which proved so popular she had to copy the design in cotton.

Opposite In January 1935 Schiap moved her business to 21 Place Vendôme. From here the House of Schiaparelli really took off as the boutique was on the ground floor, allowing customers to walk away with her prêt-à-porter clothes and matching accessories.

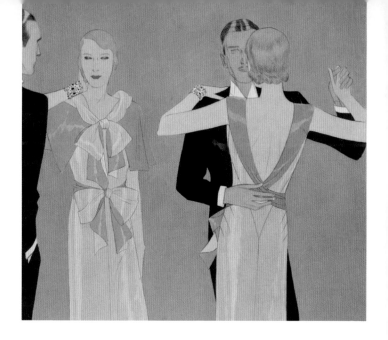

Expansion into Eveningwear

According to Schiaparelli, the first evening gown she produced turned out "to be the most successful dress of my career". Consisting of a long simple sheath dress made of black crepe de chine and a jacket in white crepe de chine with long sashes that crossed over the back and tied at the front, the silhouette was stark and the use of colour dramatic. The outfit created a sensation and was copied worldwide, something the designer took as a massive compliment to her newsworthy status within the fashion world. In 1930 she created a tiny knitted cap like a tube, which hugged the contours of the skull and immediately caused a furore when worn by the actress Ina Claire. An American manufacturer copied the newly named "Mad Cap", and made millions from mass production, which resulted in Schiap destroying her own stock and insisting the sales girls never mention it again. It was inevitable that her constant outpouring of creativity would be seized upon and copied by the rag trade; Schiap found it both flattering and infuriating in equal measure, but was unable to control it.

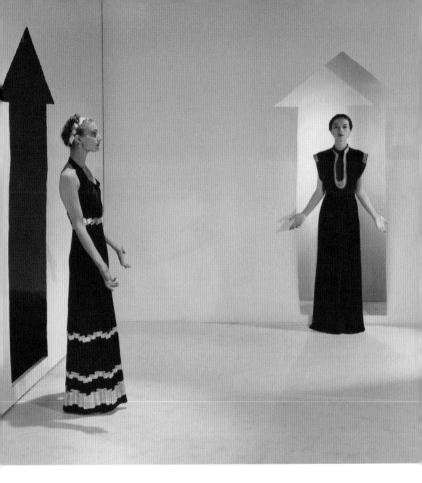

Opposite Strong use of colour and a languid silhouette often defined Schiaparelli's eveningwear. Two views of this sleeveless gown in shades of nasturtium show the deep V back and ribbon-tied bow at the front. The optional crepe satin cape covers bare arms and also has a large bow to mirror the waist.

Above Black and gold was a favourite combination, as shown in these two dresses from 1936. The model on the left wears a black satin sleeveless gown with bands of rippled gold ribbon at the hem. On the right, a simple sheath worn over satin pyjamas features gold inlaid braid.

The House of Schiaparelli |

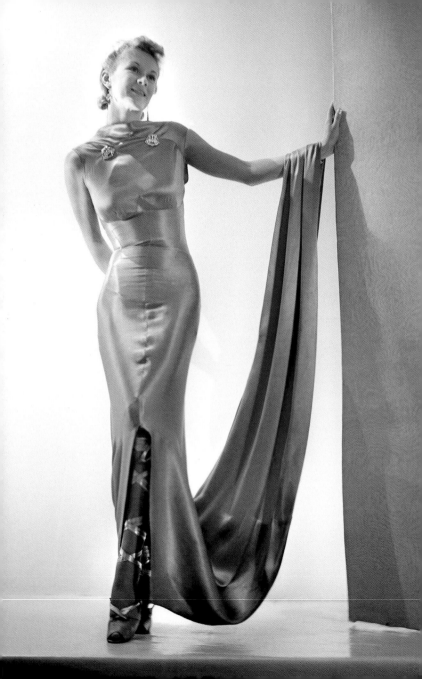

Opposite Superb cutting ensured the most simplistic of shapes would create a dramatic entrance. This strapless dress from 1937 has a fitted waist and a front slit from the knee to reveal satin-ribboned ballerina pumps. An extravagant train flips elegantly over the wearer's arm.

Right Schiaparelli often chose to cover her evening gowns with either a short cape, mini bolero or, as shown here, a much longer, more flamboyant draped cape. Both sheath dress and cape are made from shades of gold lamé, which shimmers beautifully as the light catches in the drapes and folds of the design, circa 1936.

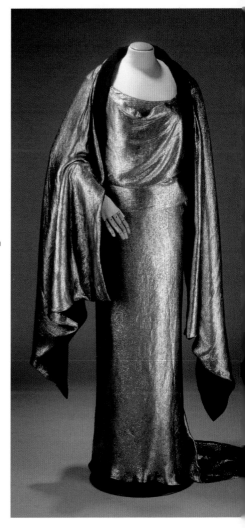

Opposite Schiaparelli often embellished her eveningwear with tiny mirrored paillettes, which dazzled as the wearer moved. The decorative panels shown on this detail of a black *marocain* evening jacket were designed in the shape of lamb chops, while the four buttons were purely decorative.

Overleaf left Schiaparelli loved to experiment with unusual fabrics and this evening coat and stole from 1938 are made of hand-sewn gilt braid that has been plaited into strips and sewn onto a chiffon foundation. Strong architectural lines of broad shoulders and tapered waist are favoured over a feminine silhouette.

Overleaf right A Chinese-influenced dramatic evening cape made from flame orange quilted taffeta, with a neat high neckline and 23 buttons. The Eastern influence extends to the cut of the grey satin gown, with its gored hemline that gently flares out to imitate the shape of a pagoda roof.

Despite the economic crash of the early 1930s, Schiaparelli continued to expand her business, and was able to provide women a moment of fashionable escape, at a time of sombre depression. Never afraid to experiment with line and detail, she constantly offered sensational clothes in bright colours and unusual fabrics. She invented a trousered evening gown and dictated slacks for dining out in. She put sequins on a mannish dinner jacket and produced suits and coats that echoed the skyscraper silhouettes of New York with straight vertical lines, barely a nod to the waist and broad squared-off shoulders achieved through padding. Influenced by menswear she produced Cossack jacket-coats and silk cloaks that owed something to those of the Venetian Doges. Heavy embroidery was used on short capes and fox and astrakhan fur utilized for interesting scarves and removable collars, all topped off with doll-sized hats. Schiaparelli's ongoing quest for originality had not gone unnoticed and regular features about her now appeared in mainstream press throughout the world. Janet Flanner's profile in *The New Yorker* in June 1932 produced the much-quoted line, "a frock from Schiaparelli ranks like a modern canvas" while *Time* magazine in 1934 declared, "Madame Schiaparelli is the one to whom the word 'genius' is most often applied."

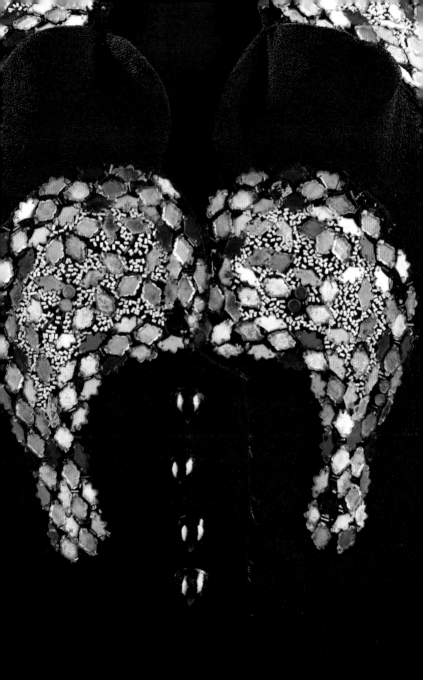

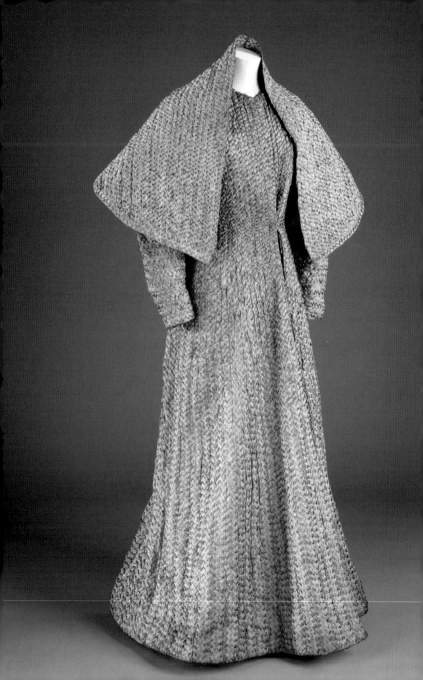

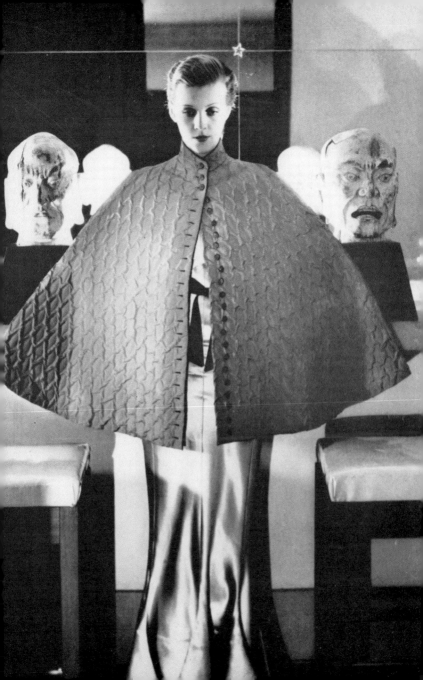

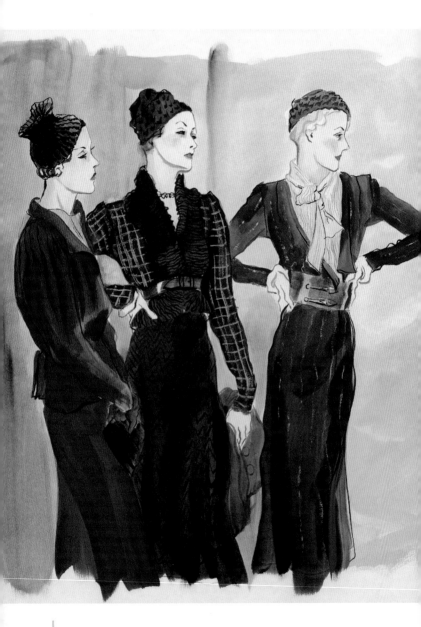

Opposite The three Schiaparelli suits in this illustration taken from a *Vogue* magazine of 1932 reflect the trend for broad shoulders and an architectural V shape that pulls into a slightly raised waist. Small tipped hats or Schiaparelli's signature knitted beret were the must-have accessories.

Right A streamlined suit made from fluid wool jersey in 1935 for a look that is softly tailored and elegant. The slim leather belt cuts over the jacket, drawing attention to the newly raised waistline. Gauntlet gloves were a Schiaparelli favourite at this time and the neat pull-on skull cap is a variation of the minicap she called the "Mad Cap".

Overleaf An illustration from the House of Schiaparelli catalogue shows part of the 1935 collection. While the smart daytime silhouette is still strongly architectural, as shown in the new hip-length box jacket and Tyrolean-type hat, eveningwear remained totally fluid and flowing in strong colours. Skirt lengths were variable for daywear and, as always, accessories played an integral role in the overall design concept. Schiaparelli's new poke bonnet (centre) was much copied.

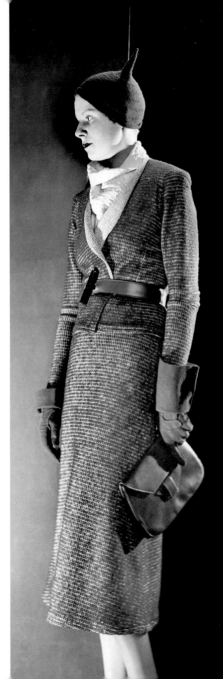

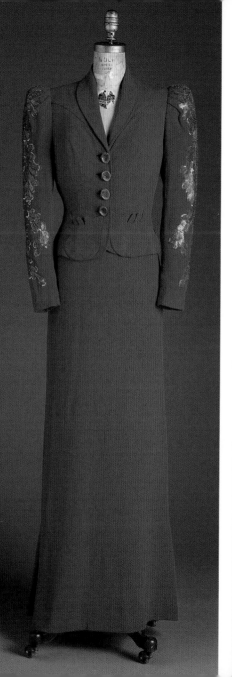

Left and below Typical of Schiaparelli's structured silhouette at this time, this magenta silk crepe dinner suit from 1938 has a floor-length dress with nipped-in jacket. The sleeve head (inset below) is very full and carefully padded to create a broad horizontal shoulder line that contrasts with the narrow line of the body. Detailed cutting on the jacket pockets echoes the shape of the embroidered leaves on the sleeves, which are all hand-stitched using gelatin and metal sequins.

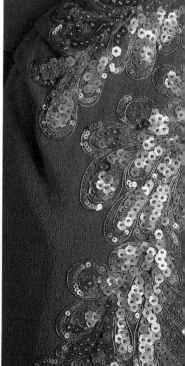

Invention in Materials

Novelty fabrics were endlessly adopted by the couturier, who had already used pigskin and ponyskin for trimmings, transparent plastic straps on a swimsuit and woven metallic thread into knits to produce a sparkly effect. Together with Jean Patou, she had embraced an elastic woollen fabric called "kasha" when it was first patented by Rodier as a material that appeared to hold the body and create a slimmer figure. Later, Schiaparelli was to use rayon, vinyl and cellophane. Collaborations with the textile manufacturer Colcombet, a pioneer of artificial fabrics, ensured she was always at the forefront of any new fabric developments. In 1932 she used a crinkled matt crepe – "tree bark" – for a whole collection and later used a rayon that resembled "oak-cork". Elsa invented waterproof taffeta and made a memorable *cape de verre* from a brittle spun synthetic known as Rhodophane, which really did resemble glass. She was also fond of paper straw for scarves and belts, monkey fur as a trimming and placed plastic zippers in the most unlikely places. The juxtaposition of the wrong type of fabric for the wrong purpose amused her and she often deliberately chose to work with materials that would cause controversy. She used Latex for gloves, oilskin for flying suits and transparent cellophane for evening bags. Bright colours, bold prints and an exaggerated line were consistently part of her signature look, whereas her rival Coco Chanel's success was based on the exact opposite: a neutral palette and simple, unstructured shapes.

Inspired by a trip to Copenhagen, where she saw women in the fish market with hats made of old newspaper. Schiaparelli produced a newsprint fabric made from journalistic cuttings about herself. Made up in all sorts of colours, in silk and cotton, the fabric was another audacious first as the designer capitalized on her own self-promotion, using it for blouses, scarves and hats, and creating another success story for the manufacturer Colcombet, who sold thousands of yards of the unusual print.

Overleaf Always keen to experiment, Schiaparelli often used animal fur and even plaited horsehair. Here, she covers the front of a fitted black sweater with monkey fur. The suede ankle boots, also trimmed with cascading monkey fur and part of the same 1938 collection, were made in collaboration with André Perugia.

No. 21 Place Vendôme

By the time she moved into her new premises at No. 21 Place Vendôme in January 1935, Elsa Schiaparelli was a fully-fledged star. A new design era came into being as her boundless creativity and fantastic imagination – what she called the "cascades of fireworks" – were forcefully unleashed in this new venture. Her success brought with it a daredevil approach: her indifference to what people thought gave her the freedom to totally express herself without fear. Here in the centre of sophisticated Paris, under the watchful gaze of Napoleon Bonaparte, she launched her first Schiaparelli Boutique.

The idea was revolutionary at the time and although it was soon copied by others, it was Schiap who first realized the potential of having a ground-floor shop where wealthy clients could simply walk in and buy off the peg. The prêt-à-porter concept was totally unique to Schiaparelli and it was not only garments the customer could try on

and take away. The boutique stocked everything a fashionable woman could want, all in one place: interchangeable separates, evening sweaters, skirts, blouses and lingerie. The designer also offered an expanding range of accessories. Bags, shoes, scarves, fake jewellery and her range of perfumes were all displayed for women to pick up and buy. The new boutique, like many of her projects, challenged the existing conventions of a couture house. Her idea was derided by competitors, but Elsa of course was ahead of the game. Today we take it for granted that all the big fashion houses promote their brand through products such as sunglasses, hosiery and key rings, but in 1935 the concept was totally innovative.

Opposite This long brown crepe evening gown with gold braid trim provides a perfect example of the shock tactics for which Schiaparelli became famous. The dress, from 1936, is demure in some respects – high-necked and cut to the floor – but the designer has emphasized the breasts by placing two circular pads of gathered and ruched material on the outside, drawing the eye directly to the bosom in a provocative way for the time.

Overleaf left Although she loved colour, black was also a favourite with the designer, and a colour she often wore herself. The simplicity and versatility of this simple crepe dress provides a perfect backdrop for the stunning embroidery. A spray of perfect white lilies was made up from various sizes of pearls and sequins with metallic strip for the stems, all hand-stitched by the specialist embroidery company Lesage in 1940.

Overleaf right This summer dress from 1939 was worn by socialite Millicent Rogers, a devotee of Schiaparelli's designs. Made from crepe rayon, the pairs of embroidered keys reference the designer's fascination with heavenly themes (here, they represent Peter's "keys of the kingdom of heaven" received from Christ). The low-scoop neckline and puff sleeves are constructed from pearl bead lattice work, studded with jewels, and reference sixteenth-century decoration as seen on Catherine de Medici's clothing.

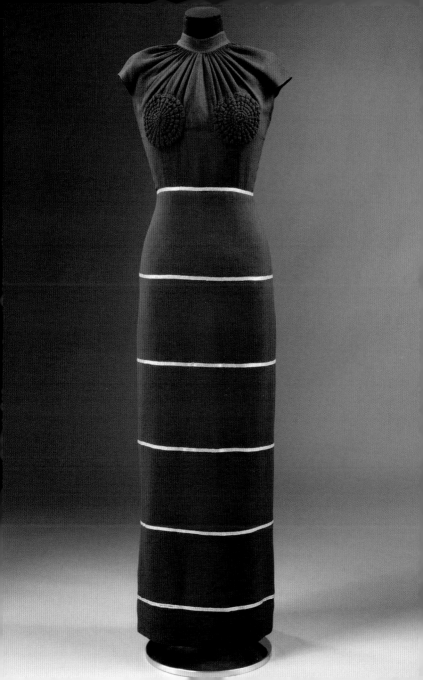

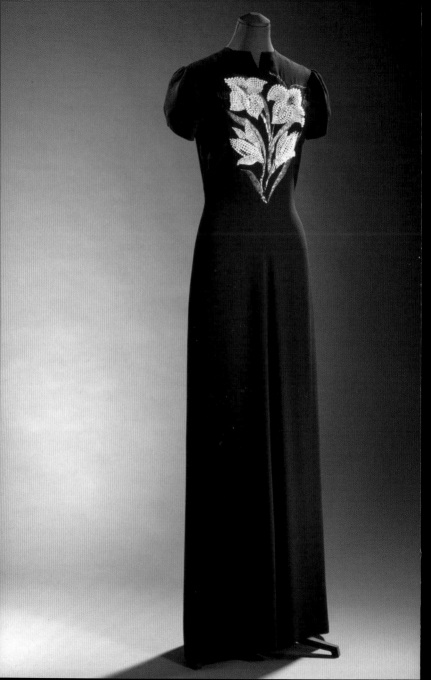

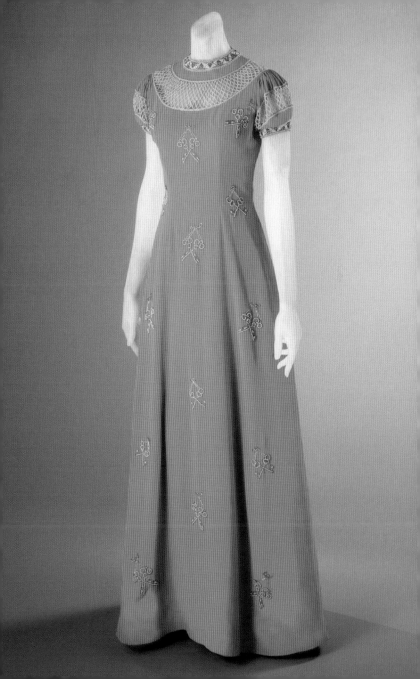

Colour

"Life-giving, like all the light and the birds and the fish in the world put together, a colour of China and Peru but not of the West."

Elsa Schiaparelli, on the colour she named "shocking pink"

Colour would always dominate Elsa Schiaparelli's vibrant life and it became something of a trademark for the House, from the introduction of ice blue through to the exotic shades she insisted on using at the tweed factories on the Isle of Skye: periwinkle, lettuce green, rose lavender and burnt orange. Elsa craved dynamic colours and tried to recreate them from the ceremonial garments she had seen in Rome as a child and the striking colours viewed later in the paintings of the Fauvist artists.

Endlessly experimenting and constantly pushing for something that commanded attention, the creation of Schiaparelli's most famous colour came after many attempts to find the right shade. In *Shocking Life* she recalls that she knew instinctively exactly what she wanted: "The colour flashed in front of my eyes. Bright, impossible, impudent, becoming, life-giving, like all the light and the birds, and the fish in the world put together, a colour of China and Peru, but not of the West – a shocking colour, pure and undiluted."

When her creative craftsman (the man responsible for baking so many of her buttons) Jean Clement added a streak of magenta to a pink he had already made – the explosive, shocking pink was born. Wowing Paris and the world, it would forever be associated with Schiaparelli.

Opposite This shocking pink dress is complemented by a dark plum, silk velvet evening jacket, embroidered by Lesage. From the winter 1937–38 collection, the detailed embellishment consists of silk and metallic threads with sequins.

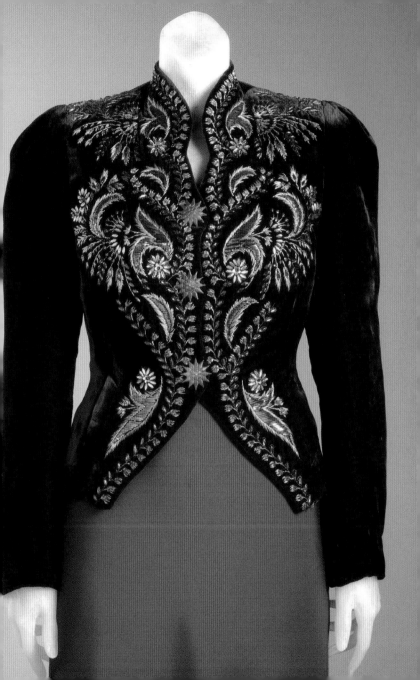

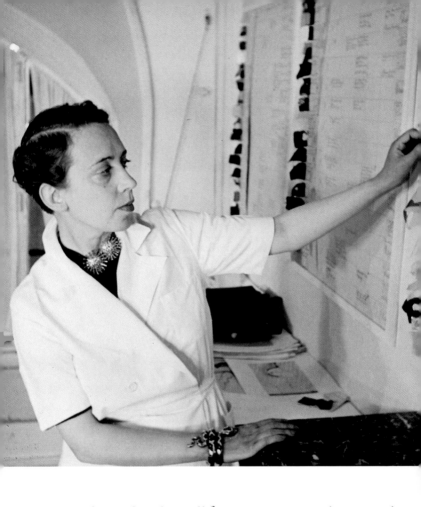

"Fashion is born by small facts, trends or even politics, never by trying to make little pleats and furbelows, by trinkets, by clothes easy to copy, or by the shortening or lengthening of a skirt."

Elsa Schiaparelli

The Collections

From the mid-1930s on Elsa Schiaparelli showed each collection as a themed event comparable to a modern-day fashion show. She used dramatic lighting, music and dancing to present her shows, which owed much to theatrical performance and were not to be missed. Stop, Look and Listen was the first collection she presented from Place Vendôme and the title spoke volumes about Schiaparelli's intention to make the world sit up and take notice of her.

It included multicultural influences, which manifested themselves in the most diverse collection of clothes: tweeds from England for eveningwear, embroidered saris in heavy crepe, padlocks for suits, glass dresses, a black evening dress inspired by an Ethiopian warrior's tunic and buttons made from gold sovereigns and French Louis d'or, to mock the next French currency devaluation. She also used zips for the first time and although not the only couturier to experiment with this new invention, Schiap was certainly the most flamboyant, using them for decoration as well as practicality and putting them on everything from eveningwear to hats and gloves.

Fascinating ideas exploded into a series of grand themes, each one more daring than the last, and though not always entirely successful, they were certainly surprising, each an inventive whirlwind of wit and folly. The Eskimo collection, not surprisingly, made the body appear bulked up and it was not a huge hit with customers, although the suede-lined fur gloves certainly were.

Butterfly motifs provided endless variations on a theme for her Metamorphosis collection for spring/summer 1937, which proved much more successful. Examining every possible connotation of a summer garden, Schiaparelli created singing birds, buzzing bees and fluttering sequinned butterflies.

Opposite Schiaparelli in her studio in 1938, studying the charts for her new collection.

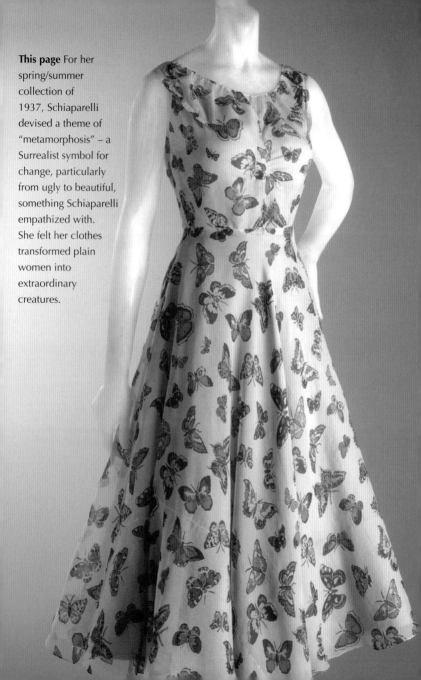

This page For her spring/summer collection of 1937, Schiaparelli devised a theme of "metamorphosis" – a Surrealist symbol for change, particularly from ugly to beautiful, something Schiaparelli empathized with. She felt her clothes transformed plain women into extraordinary creatures.

This page Schiaparelli often took inspiration from around the globe when designing and simply reinterpreted a traditional style she found. The Peruvian *chullo* (right), *montera* (below) of wool and braid, and armlets known as *punos*, which were lavishly embroidered and worn with evening gowns, were designed in 1937. Elements of the *tapadas Limeñas* (main pic), eighteenth-century women from Lima who covered their bodies with long skirts and hid their faces with long veils, also inspired her designs for this year.

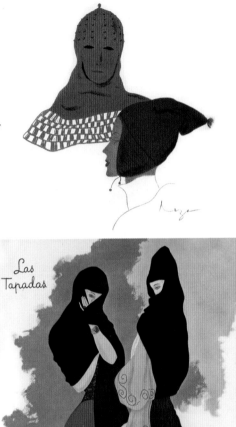

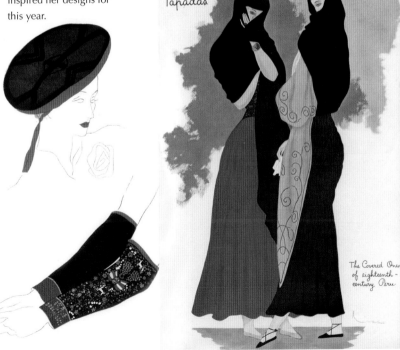

Las Tapadas

The Covered Ones
of eighteenth-
century Peru

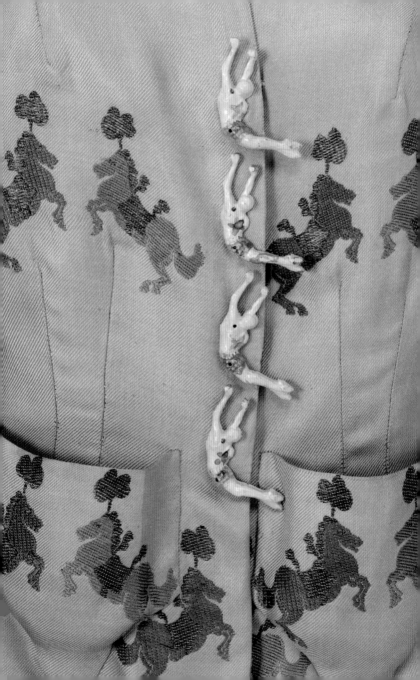

"She alone could have given to a pink the nerve of a red ... a neon pink, an unreal pink ... Shocking Pink!" Yves Saint Laurent

Inspired by the elaborate showmanship of PT Barnum, the Circus collection of spring/summer 1938 was the most ambitious to date. Riotous, swaggering and splendidly over the top, Schiaparelli presented a cavalcade of dancers, acrobats and jugglers, jumping in and out of the windows, tumbling down the stairs and dancing madly in the dignified salon showrooms. There were bright satin boleros, fitted ringmaster jackets with oversize high collars, tights worn under long black narrow skirts, dazzling bejewelled bodices and Dalí's ripped chiffon Tear dress. Detailed embroidery depicted dancing horses, flying acrobats and pirouetting elephants; Schiaparelli also went wild for circus-themed accessories. Buttons shaped as candyfloss, peppermint sticks and jolly clowns competed with handbags shaped like balloons and ice-cream cone hats. Most importantly, not a single wealthy customer walked critically away from the show and Schiaparelli gained a lot of new fans.

Opposite and right Four acrobat buttons in cast metal leap from this bright pink fitted jacket by Schiaparelli; the buttons have a unique fastening as they are anchored with brass screws that slide into industrial hooks. The silk twill has a woven repeating pattern of rearing horses in two shades of blue with their saddles, manes and plumes picked out in metallic thread. Renowned jewellery designer Jean Schlumberger produced the accompanying buttons, as well as clown fur clips and costume jewellery, for the collection.

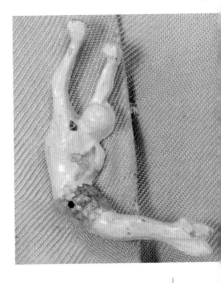

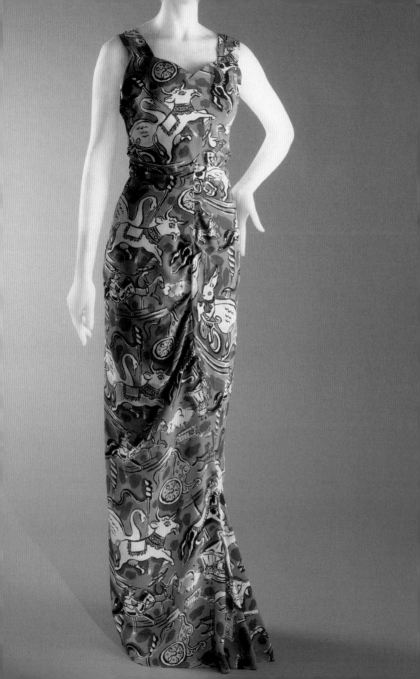

Opposite The Circus collection of 1938 was one of the most imaginative and successful themes for Schiaparelli. This blue printed silk evening dress is covered in larger-than-life drawings of carousel creatures, dancing horses and white rabbits, all designed by the artist Marcel Vertès. Colour clashes of pink, purple, yellow and orange present a childlike vision of the circus atmosphere.

Below Detail of a tailored wool jacket, designed for the Circus collection in 1938, with coloured glass and metal appliqués on the front. The four dancing horse buttons are made from cast metal and hand-painted. Behind the detailed appliqués there are concealed pockets, cut into the front of the jacket.

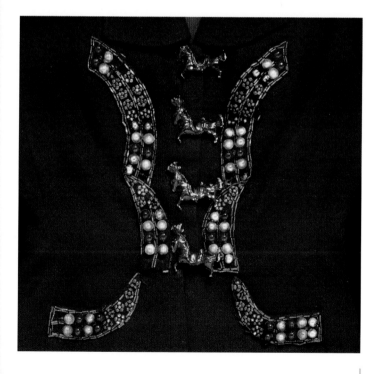

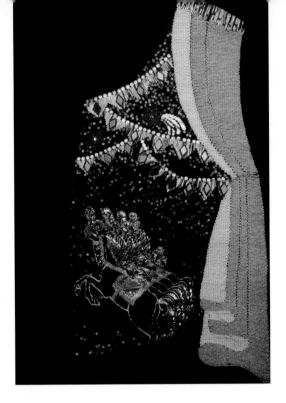

Above A detail from an embroidered jacket made of velvet, metallic thread, glass beads and rhinestones, designed by Schiaparelli for the Circus collection and executed by the House of Lesage – the perfect marriage of a visionary couturier and a master embroiderer. Several versions of jackets were made for the collection, including a lavishly decorated bolero with a row of dancing elephants, famously worn by the make-up guru Helena Rubinstein.

Opposite The stark black crepe Skeleton dress, a collaboration between Salvador Dalí and Schiaparelli for the Circus collection, used an ingenious form of trapunto quilting to create padded ribs, spine and leg bones. Most likely inspired by the Surrealist preoccupation with the human body, the skeleton motif has since been reincarnated in countless forms on the catwalk by designers such as Alexander McQueen, Christian Lacroix and Rodarte.

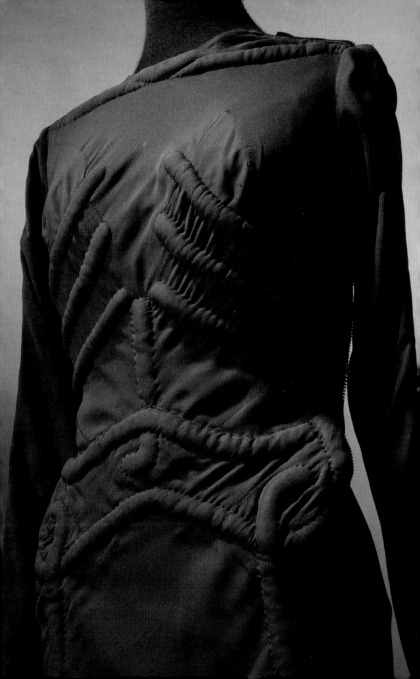

In April 1938 Schiaparelli showed the Pagan collection. Models were dressed as if they had fallen out of a Botticelli painting, with wreaths of delicate flowers embroidered onto simple classical gowns. Later she showed the Zodiac collection, which delved into astrological imagery. Rich dark velvets were studded with metal and rhinestones in the shape of the Great Bear constellation. Strong on dramatic colour, and lavish golden embroidery, the sun, moon and stars glittered on evening frocks and coats. Memorable from this collection is the Christian Bérard sketch of three women in evening dress, the central figure with her back turned to show the elaborate golden sun embroidered onto a hip-length silk cape.

Below The autumn 1938 Pagan collection featured ideas drawn from nature. This typically Surreal choker, which is made from gold grosgrain ribbon, decorated with purple velvet bows and hanging gilt pine cones, perfectly encapsulates Schiaparelli's desire to shock.

Opposite Made from silk crepe, the neckline and bodice of this black dress are decorated with creeping foliage interspersed with pretty pink flowers and falling petals. Beautifully executed in plastic and silk thread, the embroidery was produced by Lesage.

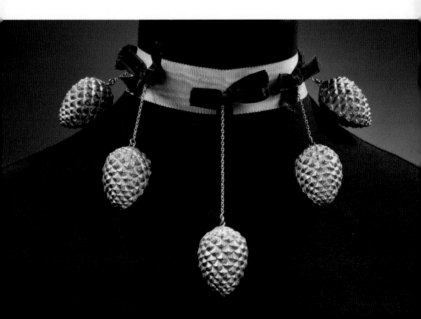

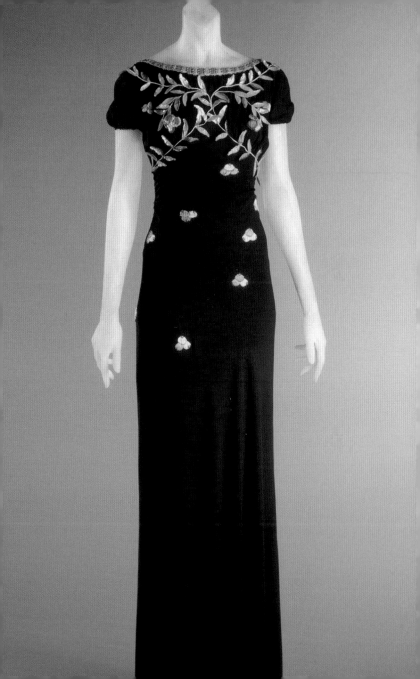

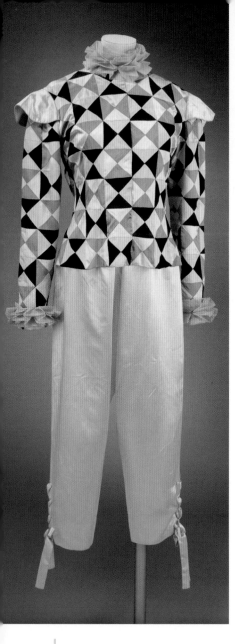

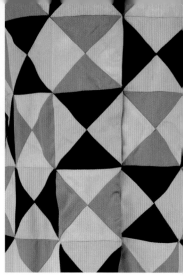

Left and above Before launching his own label in 1952, Hubert de Givenchy worked for Schiaparelli and this Harlequin costume was his first design for the fashion house. Worn for a fancy-dress ball in Venice, the playful ensemble consists of a satin patchwork jacket with detachable ruffles at the neck and wrists, plus cropped pants with laced ribbons at the hem.

Opposite A dramatic evening gown from 1939 cleverly creates a softness from the severity of the stripes with the inclusion of a shaped bustle. The bustle was constructed by folding two rectangular pieces of fabric in half, then pleating them back into the seam at the waistband.

Schiaparelli created the Music collection – jumping musical notes and bars scattered among embroidered musical instruments – for autumn 1937. Details and accessories always provided the opportunity for folly that so appealed to her, and she created bags shaped like an accordion and a suede belt that had a treble-clef buckle. One particularly striking evening dress, embroidered all over with metallic thread forming bars of music and exquisitely detailed tambourines and violins, had a belt with a working musical box as the buckle.

Schiaparelli's last great collection, the Commedia dell'Arte, was flooded with colour and presented to the strains of Scarlatti and Vivaldi. Drawing loosely on an improvisational comedy that toured Italy in the sixteenth century, the designers used actors' traditional costumes as a springboard to reinterpret costume into fashion. Tutu skirts and shocking pink hosiery were paraded playfully alongside the narrowest of suit silhouettes, while the wandering minstrels wore big bulky topcoats with sharply contrasting coloured linings. Pompoms, ruffles, masks and dramatic tricorn hats provided the fun element, but it was the wool harlequin coat with its dramatic use of colour and geometric design that stole the show. The inspirational colour blocking of Man Ray's celebrated painting *Le Beaux Temps,* 1939, was a source of influence for this collection.

From 1935-39 Schiaparelli was the designer to be seen in, but the outbreak of war broke the spell, and things were never quite as good again.

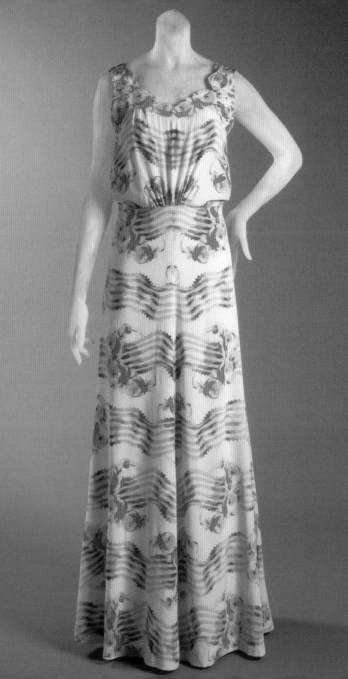

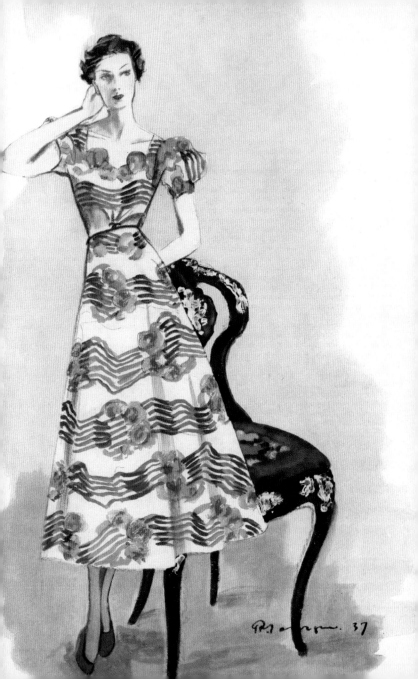

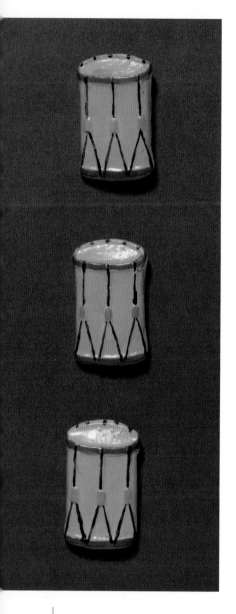

Previous pages Two variations of a white silk dress, printed with a freehand style interpretation of sheet music, using ribbons for bars and roses as notes. The dress on the right was seen at Elsa Maxwell's Red, White and Blue Ball of 1937.

Left Schiaparelli excelled in making inventive buttons that were shaped into every conceivable object except plain rounds. Here, plaster-cast buttons in the shape of a drum were used in her Music collection of 1937. Jean Clement, who worked in Schiaparelli's studio, was responsible for the production of most of her outlandish buttons and was often known to bake them in the oven.

Opposite Variations on a musical theme adorned all the clothes in the Music collection of 1937. Detailed embroidery from Lesage included sheet music motifs, with notes and instruments all in perfect detail. This purple chiffon gown is softly ruched across the shoulders and bodice, falls smoothly over the waist and hips to a fuller skirt with loose inverted gathers. The embroidered ribbon detailing that falls around the hips depicts hanging cymbals, a violin, horns and a piano keyboard.

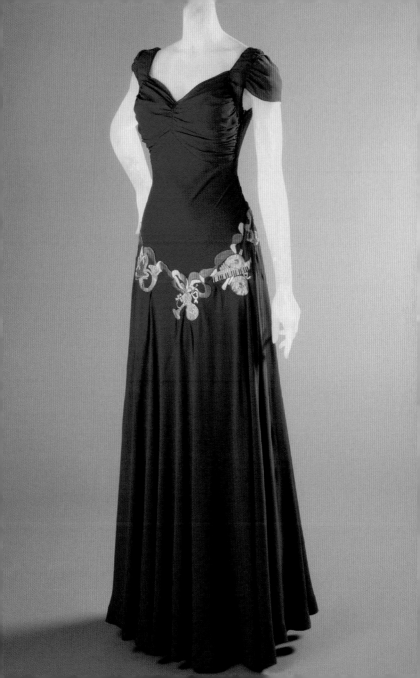

Below These silk crepe gloves were made to match the evening gown featured on the previous page. They exhibit the detailed embroidery by Lesage, made with both metallic and silk threads, plus tiny seed pearls to decorate the tambourine.

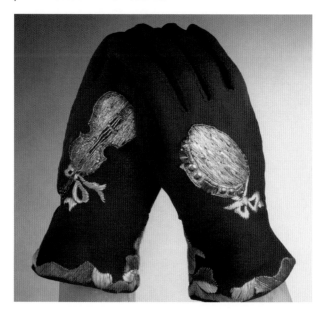

Opposite This famous illustration by Christian Bérard was shown in *Vogue* magazine in 1938, the year Schiaparelli created her Zodiac collection. The three evening ensembles were dramatic in colour and design. Rhinestones in the 12 signs of the zodiac shone out from a midnight blue velvet jacket, while the Medusa head in the shape of the sun, designed by Bérard, dazzled on the back of the shocking pink cape. Lesage produced the pink Phoebus cape design, in gold tweed and sequins.

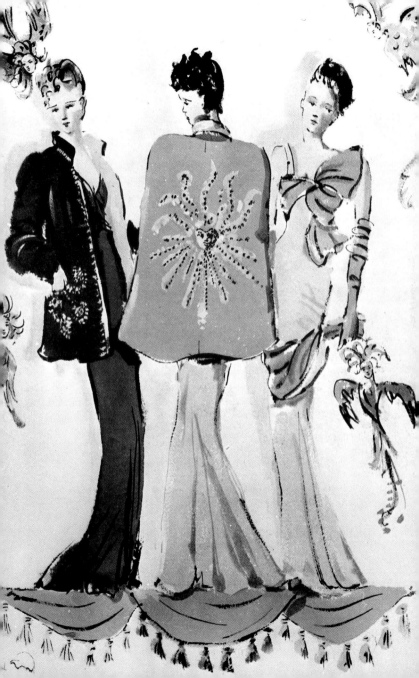

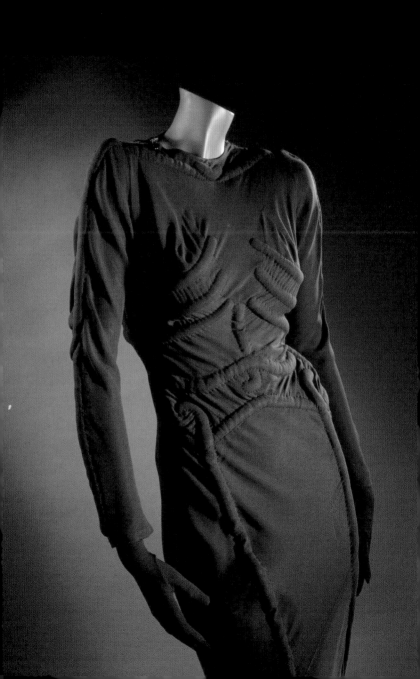

Fashion and Art

Gabrielle "Coco" Chanel, on Elsa Schiaparelli

The first artistic group that Elsa Schiaparelli met socially in 1919 were part of the international Dada group who had converged on New York to escape First World War. Their art was diverse, shambolic, nihilistic and outrageous, but more importantly and perhaps what struck a chord with Schiaparelli, was the philosophy that united the various artists, poets and performers. Dada challenged the conventional notions of what art should be it took established convention and turned it on its head, appropriating found objects and printed literature and re-presenting both with either a political or ironic message. Nonsense, craziness and a desire to tease and shock were all Dada traits that could equally well refer to so many of the successful collections of Schiaparelli.

Many years later in Paris, it was another group of avant-garde artists, including Man Ray, Meret Oppenheim, Salvador Dalí and Jean Cocteau, whose artistic outpourings not only inspired Schiaparelli, but gave her a great sense that her own artistic creativity was understood. She claims her friendships with these talented artists not only provided a source of exhilaration and support, but lifted her "from the boring reality of merely making a dress to sell".

Schiaparelli was in the business of selling glamour and did so most successfully through her exuberant, humorous and often outrageous

Opposite Unsurprisingly this collaboration with Dalí, known as the Skeleton dress, met with public outrage when it was first shown as part of the Circus collection of 1938. Trapunto quilting is used to suggest rib and hip bones and the design was stitched in outline through two layers of silk crepe and then padded with cotton wadding to create the "bones" on the front.

Overleaf Schiaparelli, with a model, has the Lobster print dress, designed by Dalí, on her lap.

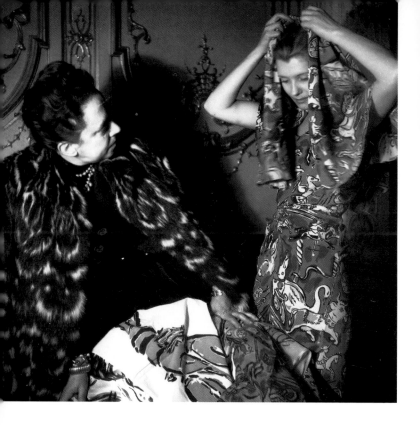

creations. She liked visual jokes and gags and her imaginative spirit produced work that sometimes relied heavily on the absurd. In this she had much in common with the Surrealist artists. Far from simply adopting some of the Surrealist ideas into her own work, Schiaparelli led the way in a dialogue that opened up the connections between art and fashion. She specifically commissioned artists like Christian Bérard, Jean Cocteau and Leonor Fini to design fabrics, buttons, scent bottles and advertisements. Like the Surrealists she deliberately set out to create optical illusion and to make the mind question the perception of reality.

Surrealism was creeping insidiously into the visual culture, particularly through the pages of woman's magazines such as *Vogue* and *Harper's Bazaar*, where illustration and photography captured the symbiotic relationship between fashion and art. The arrival of the first International

Surrealist Exhibition in London of June 1936 confirmed the relationship, as Salvador Dalí turned up wearing a deep-sea diving suit to deliver a speech. Confounding expectations, exploring visual irony with incongruous details or prints and disrupting the conventional meaning of fashion are all ideas that translate to Schiaparelli's oeuvre.

The legacy of Surrealist art is it developed ideas that connect the thinking of modern psychoanalysts with visually disruptive, sometimes distorted images. Visual and verbal imagery that is fantasy-based and delves into the subconscious confronted the viewer with a different sort of reality, causing an unsettling confusion. While the commerciality of creating fashion was considered far less worthy of theoretical analysis, the collaborative work between the Surrealist artists and Schiaparelli explored the boundaries and functions of dress in many different ways and it seems oversimplistic to presume Schiaparelli's contribution was simply a nod to the witticism of Surrealism to amuse her rich clients.

Elsa and Salvador

Schiaparelli's most memorable collaborations are with the Spanish artist Salvador Dalí, who throughout the late 1930s embraced popular culture, commerce and every aspect of contemporary fashion. The partnership was rewarding for both artists, as Schiaparelli was known for her love of shock tactics and for her willingness to challenge the conventions of beauty and gender stereotypes. The Surrealist Desk suits and coats were thought to be based on a 1936 Dalí painting *The Anthropomorphic Cabinet*, which showed a naked man seated on the floor, with a torso resembling a chest of drawers, all open to various degrees with bits of fabric spilling out. The tailored Desk suit, famously photographed by Cecil Beaton in a painted Surrealist landscape, has multiple boxy pockets all over the front of the jacket, with large drawer knobs where the buttons might be. A single pocket has a practical purpose, but multiple pockets? Deliberate confusion, as some are real and are some fake, an idea that may have less to do with practical jokes than with the designer choosing to subvert the function of fashion and cause disharmony.

The Surrealist theory of displacement is best exemplified in the extraordinary Shoe-Hat that Schiaparelli and Dalí created together. Although the idea is thought to have originated from an earlier photograph of Dalí standing with a shoe on his head (taken by his wife Gala), the upside-down hat, which balanced seductively over the forehead, was just one of many crazy millinery creations that Schiaparelli produced in the 1930s. Realistic objects of a television, a birdcage and even a lamb cutlet with a white frill over the bone were all appropriated into outrageous, but never foolish hats.

Controversy greeted the next two collaborations, with the organza Lobster dress (1937) and the Tear illusion dress (1938) both becoming iconic. The lobster was a recurring theme and already a Dalí favourite, having been seen in his painting from 1935, *New York Dream – Man Finds Lobster in Place of Phone*, and used again, later, on the handset of his *Aphrodisiac Telephone* made for Edward James. Dalí's famous lobster print appeared as the focus of attention, positioned provocatively on a simple white evening dress with little other decoration to distract.

Opposite In spring 1937, Schiaparelli asked Dalí to design a lobster as decoration for a white organdy evening gown, which was interpreted into a fabric print by the leading silk designer Sache. From 1934, Dalí began incorporating lobsters into his work, including *New York Dream – Man Finds Lobster in Place of Phone* and the mixed-media *Aphrodisiac Telephone* (1936). The Lobster dress was made famous when it appeared in *Vogue,* modelled by Wallis Simpson.

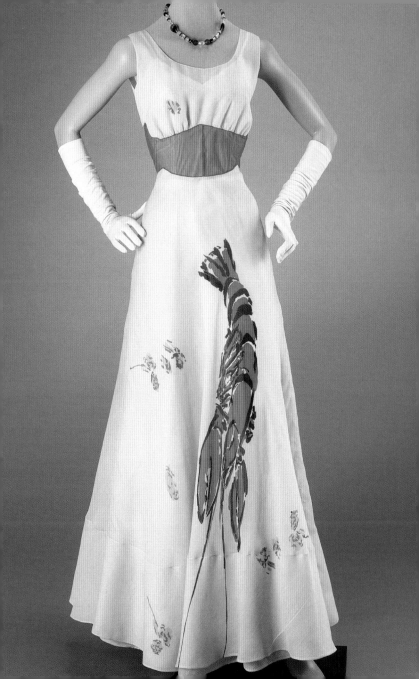

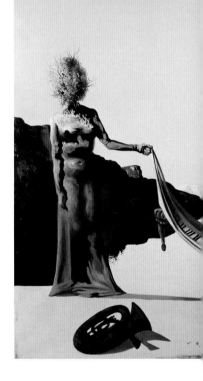

Right Dalí's famous work from 1936, *Three Young Surrealist Women Holding in their Arms the Skins of an Orchestra*, which is thought to have provided inspiration for the Tear dress, on which he collaborated with Elsa Schiaparelli in 1938. The central figure wears a white dress resembling flayed skin.

The juxtaposition of innocent white floaty dress and a blood-red, super-sized lobster placed strategically between the thighs, left little to the imagination. Dalí's work often dealt with themes connecting sexuality and consumption, and here Schiaparelli aligns herself with the same ideas, executed not through painting but through the creation of a couture dress. The dress was shocking; it subverted questions of taste and played on the displacement of an object in an overtly sexual way. Elsa did not mention the dress in her autobiography, but after it was worn by Wallis Simpson, and photographs of her wearing it circulated throughout the world, the Lobster dress became one of Schiaparelli's most famous designs.

The Tear dress was presented as part of Schiaparelli's Circus collection of 1938 and may have been inspired by an earlier work of Dalí's: *Three Young Surrealist Women Holding in their Arms the Skins of an Orchestra*. The floor-length gown, which was made from pale

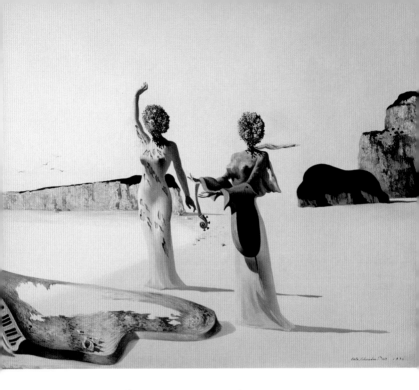

blue silk crepe (since faded to white), gives the appearance – using a painterly trompe-l'oeil effect – of torn and shredded pieces of fabric that have been ripped from the dress and left to hang in ugly tears. But the ravaged print causes confusion. Is it designed to resemble flayed animal fur on the inside, or are the colours suggestive of bruised flesh? Perhaps the print was designed to show that the dress was worn inside out, revealing the "right side" of the fabric only on the hanging rips. To further disorient the viewer and extend the puzzle of reality versus illusion, the matching headscarf had real three-dimensional tears sewn onto the fabric. Uneasy contrasts between the function of the beautiful evening gown and the shredded fabric confound on many levels. The rips give the illusion of exposure and possibly vulnerability, while the "torn" fabric suggests a level of violence, juxtaposing luxurious wealth with rags and poverty. It may even have been a sombre portend of the imminent war ahead.

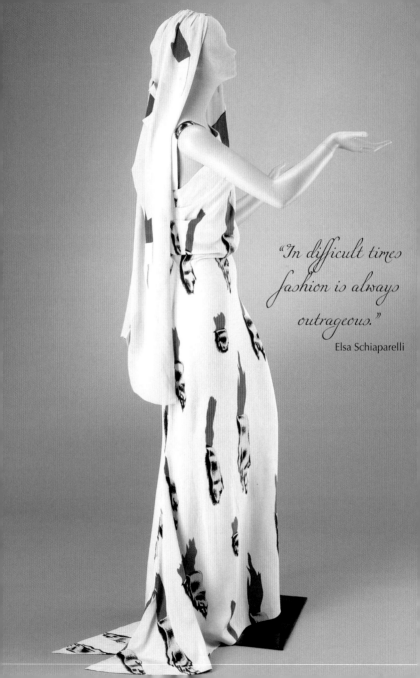

"In difficult times fashion is always outrageous."

Elsa Schiaparelli

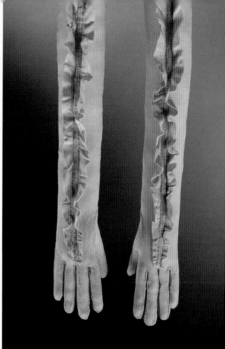

Opposite and detail above The Tears dress of 1938, inspired directly from a Dalí painting that showed a figure in ripped skintight clothing disturbingly suggestive of flayed flesh, is a mourning gown and veil designed by Schiaparelli just prior to the Second World War. This fabric, itself created by Dalí, looked as if it had been savagely and repeatedly torn, but is in fact printed with the rips carefully cut out and lined in pink and magenta. Images of fur incongruously lining the rips of the printed dress, add a bestial tone to the work.

Above Designed to be worn with the Tears dress, opposite, the strong pink of these gloves would have complemented the pink and magenta print of the dress. Schiaparelli had a knack for using unusual details and trimmings to make the everyday item appear extraordinary. Here, instead of a traditional glove leather, a stretchy pink crepe fabric was used, precluding the need for buttons or fastenings. The dramatic shirred ruffles, running the length of each glove, provide an additional unexpected touch.

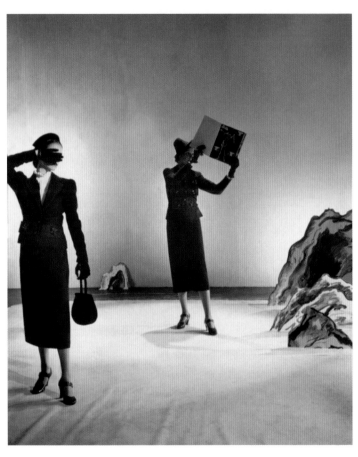

Above Surreal fashion shot taken by Cecil Beaton in 1936. It shows two of Schiaparelli's Desk suits, designed with multiple pockets positioned all over the jacket, some of which were real, others fake. Real drawer knobs were used in place of buttons.

Right *The Burning Giraffe,* 1937, by Salvador Dalí was just one of many works where he explored the idea of a set of drawers spilling open from the body. These were thought to be secrets that could only be opened through psychoanalysis and represented the inner subconscious.

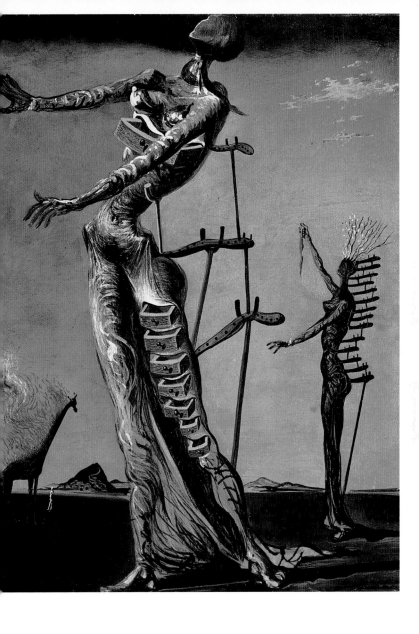

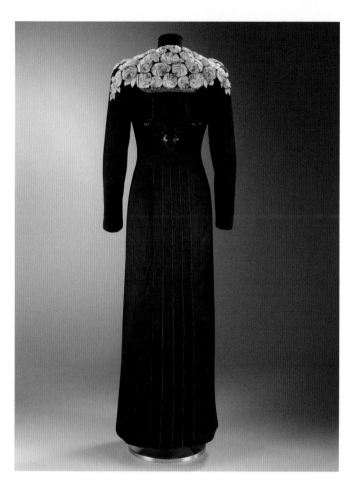

Above and opposite In 1937, Schiaparelli collaborated with Jean Cocteau on two long evening coats made from silk jersey. They differ slightly in final execution, but both display the talented draughtsmanship of Cocteau and the brilliant finesse of Lesage, who translated the idea into reality. Ambiguity comes from the two profile faces with pouting lips, which can also be viewed as a classic urn, topped with silk roses. The collaboration excels due to Schiaparelli's precision cutting of the coat.

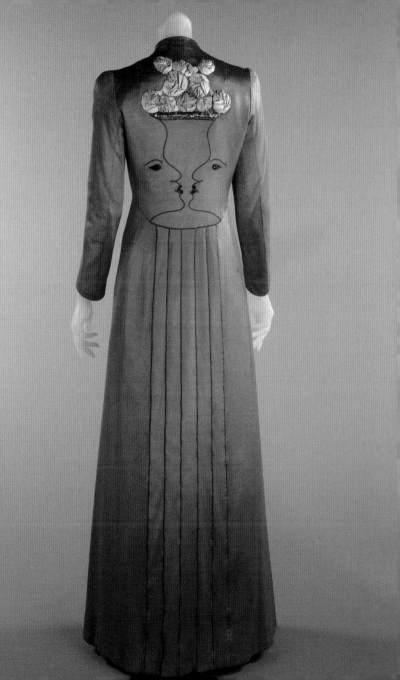

Jean Cocteau

In 1937 Schiaparelli collaborated with her close friend the artist Jean Cocteau (who also produced work for Chanel) on a complex design for an evening jacket. Cocteau, who (among other talents) was a hugely gifted draughtsman, drew the profile of a female face on the front shoulder of an asymmetrical jacket, her head thrown backward with a mane of golden hair cascading down the sleeve. A disembodied hand, which was a favourite Surrealist motif, appeared at the front waist, clutching a cellophane handkerchief, and Cocteau's perfect freestyle line drawing was beautifully embroidered in pale pink for the skin and detailed gold stitching for the hair, all executed by the Maison Lesage. The result was beautiful and unsettling, as Schiaparelli had chosen to upturn convention by choosing coarse grey linen as the basis for this elaborately embroidered evening jacket. Cocteau was also responsible for another memorable design that appeared on the back of a long fitted, silk jersey evening coat in 1937. Creating the shape of a classic urn by positioning two symmetrical female profiles facing each other, with pursed red lips almost touching, the vase itself was filled with pink silk roses, whose tight petals were wrapped around each other to give a three-dimensional effect. The beauty is in the collaboration between designer, artist and a young François Lesage, who executed the exquisite embroidery, as each is allowed to excel in their contribution to the finished product. For Schiaparelli these complex collaborative clothes always needed precision lines and she provided a perfect blank canvas to showcase the Cocteau design. The vase is positioned to sit precisely at the small of the back, the narrowest part of the coat. The long embroidered lines representing the column that the vase rests on fall elegantly down over slim hips, simply reinforcing the elegant line of the silhouette.

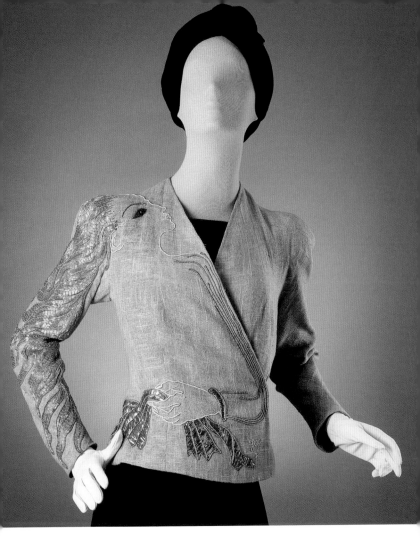

Opposite and above A fashion drawing by Jean Cocteau of 1937 shows his design for Schiaparelli's fitted jacket and long skirt, beautifully realized by Lesage in gilded metallic thread, tiny beads and paillettes. The woman's hand carrying a cellophane handkerchief, which appears prominently on the front, was a common Surrealist motif.

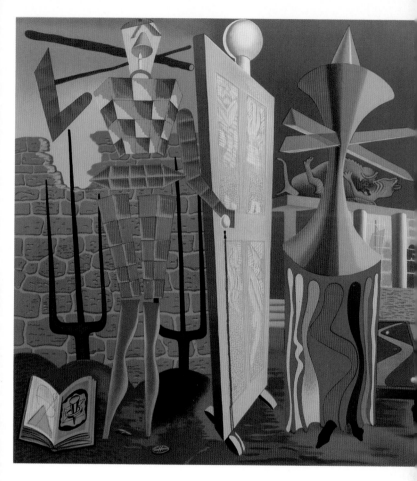

Above Schiaparelli had a wide circle of artistic friends and her work was often influenced or inspired by their output. Man Ray's painting *Les Beaux Temps*, produced in 1939, resonates with the strong use of colour blocking that she utilized in her patchwork garments from her most successful collection, the Commedia dell'Arte.

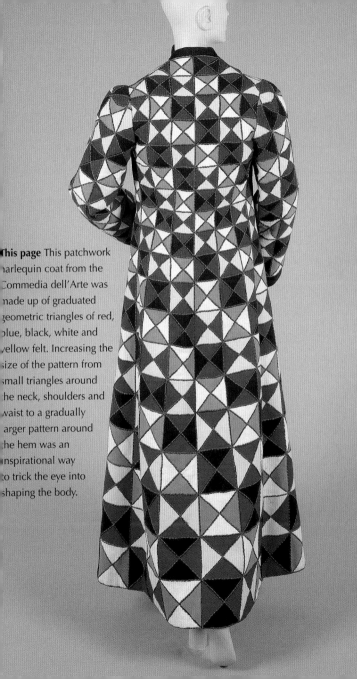

This page This patchwork harlequin coat from the Commedia dell'Arte was made up of graduated geometric triangles of red, blue, black, white and yellow felt. Increasing the size of the pattern from small triangles around the neck, shoulders and waist to a gradually larger pattern around the hem was an inspirational way to trick the eye into shaping the body.

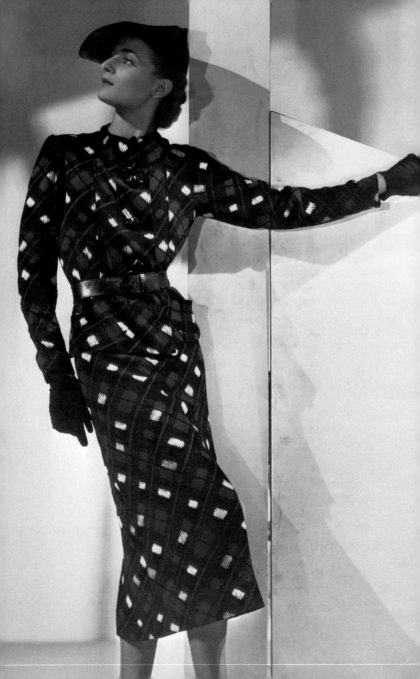

Hollywood Glamour

"Never fit a dress to the body but train the body to fit the dress."
Elsa Schiaparelli

The 1930s were the heyday of scandalous Hollywood movie stars and rich society women, who divided their time between fashionable resorts such as Cannes, St Moritz and Venice; they were also Schiaparelli devotees and regular visitors to the salon at Place Vendôme. Even in the early days Elsa Schiaparelli had worked her magic on a young Katharine Hepburn, who went on to claim in the press that this transformation had been the turning point in her career. A superb silhouette was a Schiaparelli trademark and while daytime looks were meticulously fitted and groomed, evening dresses were, in complete contrast, unspeakably seductive and languid. Those who could afford it wanted Schiaparelli to provide both.

At the height of her success the smartest seats in the salon were reserved for royalty, leaders of society and the wives of presidents. Actresses like Claudette Colbert, Myrna Loy, Norma Shearer, Merle Oberon and Vivien Leigh flocked to see the new collections. Greta Garbo was a customer, as was Marlene Dietrich, and then later Joan Crawford and Lauren Bacall. Perhaps her most famous client, however, was Wallis Simpson, who was regarded as *the* most fashionable women of her time. Her angular frame and strong face provided a perfect canvas for Schiaparelli, who had a fondness for *les jolies laides* and took pleasure in empowering the plainest of women through statement dressing. She contributed to Mrs Simpson's wedding trousseau, providing a black crepe day dress printed with little white turtles, a blue evening dress with yellow butterfly print repeated on the lapels of a blue tweed jacket, and a variation of the white organza lobster dress created with Dalí (see page 75).

Left Model wearing an outfit Schiaparelli designed for Wallis Simpson in 1937, that was to be worn after her marriage to the Duke of Windsor.

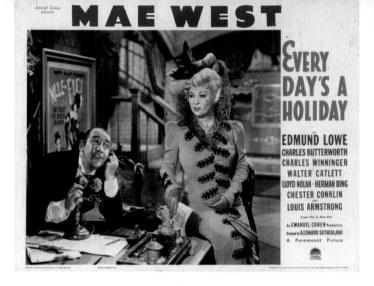

Schiaparelli had become the couturier whose clothes women wanted to be seen in; her aristocratic background ensured she was socially accepted within these circles and she turned out to be the best endorsement of her own style. Gala Dalí was a fan, as was Nancy Cunard, wealthy heiress and close friend of the Surrealists who often appeared in Schiaparelli. The Honourable Mrs Daisy Fellowes, one of Schiaparelli's best clients, shocked everyone when she turned up in leopard-print pyjamas when everyone else was wearing floaty tea dresses. She was also the only person thought to have worn the Shoe-Hat with the swagger and confidence it deserved.

The mystique of Hollywood in the 1930s and Schiaparelli's love of the dramatic produced a perfect marriage. Her clothes created high drama, with or without a movie star, and her influence on existing costume designers in Hollywood such as Gilbert Adrian and Edith Head was immense. Schiap designed the costumes for several films, starting in 1933 with the movie *Topaze*, which starred Myrna Loy, and going on to famously dress the voluptuous Mae West in *Every Day's a Holiday* in 1937.

She is also credited with being the costume designer for several British films in the 1930s, dressing Margaret Lockwood and Anna Neagle for *The Beloved Vagabond* and *Limelight*. Her last big production as a costume designer was the John Huston film *Moulin Rouge* (1952), starring Zsa Zsa Gabor, which was filmed in London and Paris.

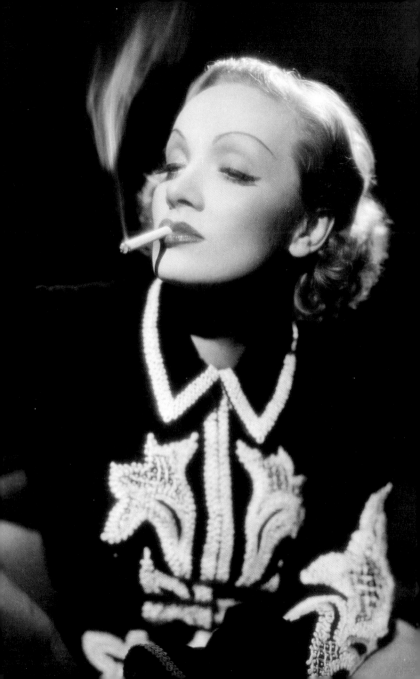

Previous left and right Publicity poster and a promotional still from the 1937 film *Every Day's a Holiday* starring Mae West. Schiaparelli was brought on board to design the costumes despite the fact that the famously buxom and curvaceous West could not have been further from the strong-shouldered, narrow silhouette that was the designer's trademark. As West was not prepared to travel to Paris for fittings, the studio sent a life-size plaster torso of her hourglass figure to Schiaparelli, along with requirements for fabrics and colours.

Opposite The German film star Marlene Dietrich in the movie *Angel*, 1937. Both Dietrich and Greta Garbo were perfect muses for Schiaparelli – their masculine-type figures were perfectly suited to show off the classic Schiaparelli silhouette.

Right The Honourable Mrs Daisy Fellowes was a celebrated socialite of the 1930s, heiress to the Singer sewing machine fortune, an acclaimed beauty and a fashion icon. One of Schiaparelli's most loyal fans, she was thought to be able to carry off even the most shocking creations. Here, she wears a white Mandarin collared coat by Schiaparelli of 1935.

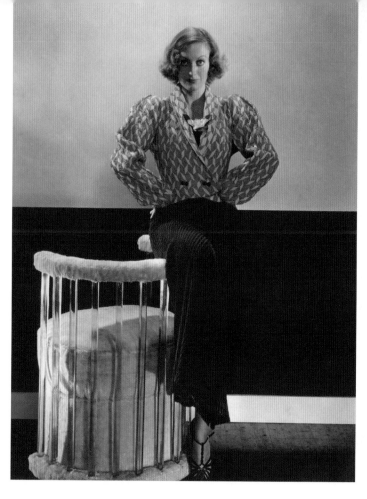

Above Photographed by Edward Steichen in 1932, the indomitable actress Joan Crawford wears an unusual combination of dark hyacinth-blue knitted woollen dress with a structured, heavily padded and quilted matelasse crepe jacket by Schiaparelli.

Opposite Socialite Millicent Rogers was a regular visitor to No. 21 Place Vendôme, where her slender proportions provided a perfect frame for Schiaparelli's sculptural pieces, such as this classic black velvet suit with detailed metallic braid edging, worn with cross fleury brooches.

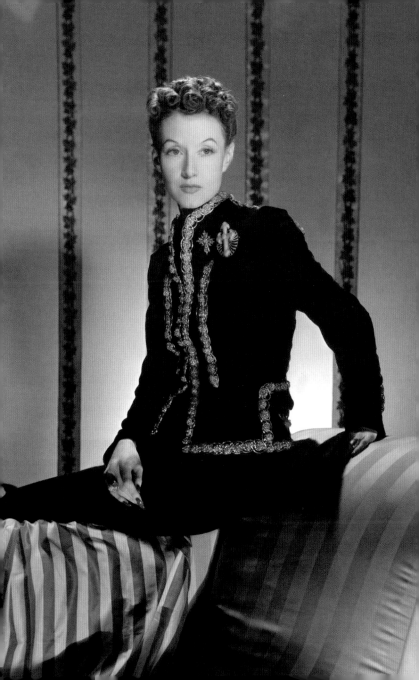

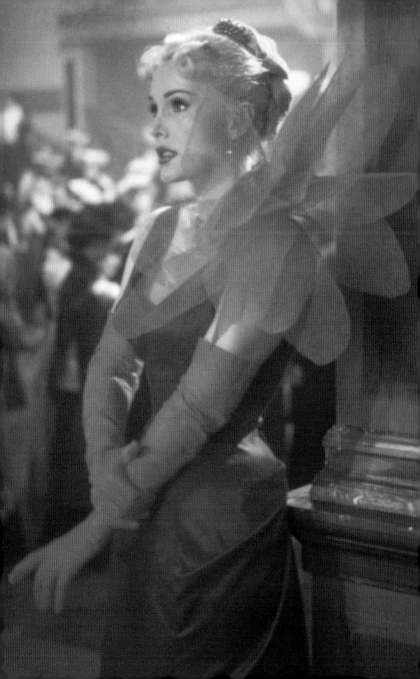

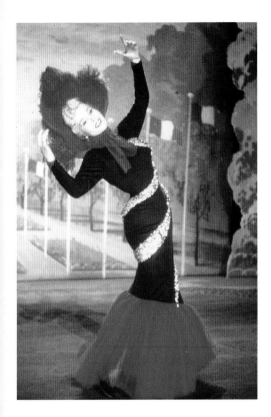

Opposite and above The Hungarian actress Zsa Zsa Gabor starred in the 1952 musical *Moulin Rouge,* directed by John Huston. It was the last film on which Elsa Schiaparelli collaborated with her friend Marcel Vertès, who was credited as costume designer. Schiaparelli, however, was certainly responsible for producing the extravagant outfits for the star and the film won an Academy Award for best costume design.

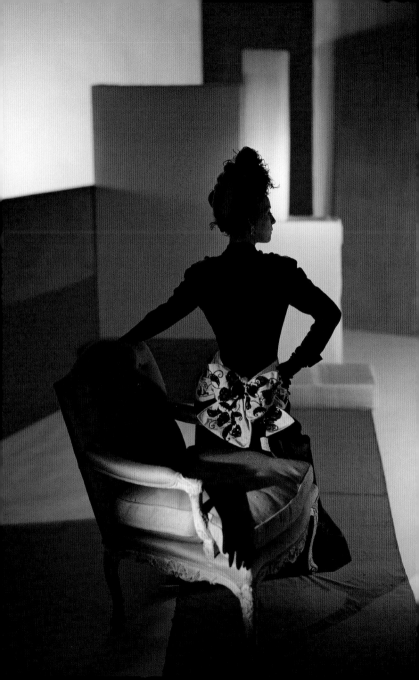

The War Years and Beyond

After the declaration of war, Schiaparelli sent Gogo to the United States, which she felt would be safer for her daughter. She carried on at the Place Vendôme with a depleted staff, her indomitable spirit and sense of humour still intact. Her last collection was called the Cash and Carry collection. Everything was designed with big pockets, so that in the case of an emergency a woman could grab everything she needed and run, leaving her hands free. There was a woollen boiler suit intended to be placed at the side of the bed and quickly pulled on for a trip to the air raid shelter, as well as an ingenious camouflage dress. Designed to look like a day dress, the wearer simply had to pull a ribbon at the appropriate time and the piece, as if by magic, lengthened into a full-length evening gown.

Determined to carry on whatever it took, Schiaparelli discussed with Captain Edward Molyneux and Lucien Lelong, the head of the Syndicat de la Couture, the possibility of moving staff out of the ateliers in Paris to a safe house in Biarritz so they could continue working. But it was not to be, and when Mussolini allied himself with Hitler and declared war on France, Schiaparelli steeled herself for the trouble ahead and vowed to do all she could to help her adopted country.

Columbia Lecture Bureau offered Schiaparelli a series of lectures that were to be illustrated with her dresses. Both Lelong and Molyneux urged her to go to America to fulfil the contract, hoping it would also help trade between the countries. The tour was considered a success, despite the fact that the ship carrying the dresses was sunk and Schiaparelli was forced to appeal to the good nature of Bonwit

Left A model wearing Schiaparelli eveningwear shows only the outline of her back view, which provides us with the iconoclastic silhouette of the stamp of the designer. Broad shoulders, narrow to the small of the back, offset by a huge embroidered pink bow, extravagantly decorated with embroidery by Lesage. Shocking pink contrasted with black was a much-loved combination.

Teller to try and replicate what had been lost. After visiting 42 towns in eight weeks, the tour ended and Schiaparelli travelled back to Paris where she found the doors to Place Vendôme still open, although operating in much-reduced circumstances. Her return was short-lived however, as her personal situation became more precarious and she was urged once again to leave the country. In May 1941, after a 20-year absence, Schiaparelli was back in New York. Although it was not the city she remembered, she encountered many friends and began working for a relief agency with all the energy and passion previously used for her business.

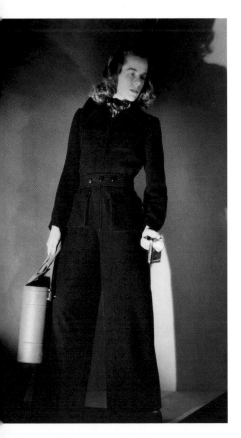

Left The last collection Schiaparelli produced before the Second World War was called Cash and Carry (1939). Always concerned with practicality, these Schiaparelli pyjamas were made to keep women warm in the air-raid shelters. Easy to take on and off, they also and had several zippered pockets to keep valuables safe.

Opposite After the war Schiaparelli continued her business and produced collections that relied less on severe padding and tailoring, more on simplicity. This elegant duster coat with easy sloping shoulders exemplifies her Hurricane line from 1947.

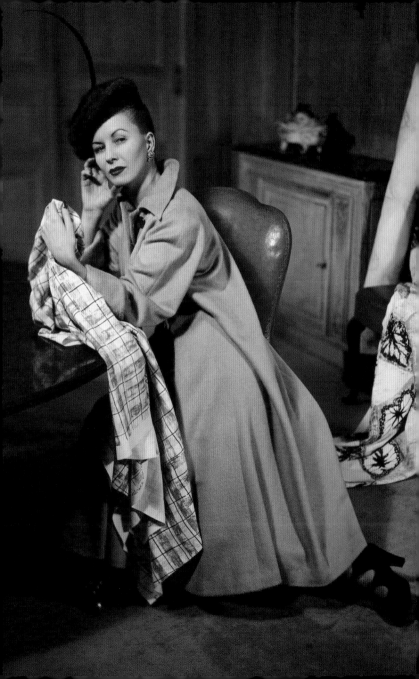

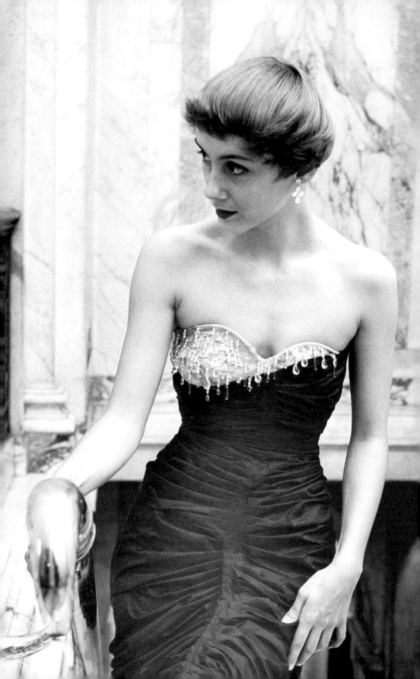

Opposite New York model Shari Herbert, shown here wearing one of Schiaparelli's evening gowns from her 1949 collection. The skin-tight sheath dress has a central seam with soft gathering around the waist and hip areas. Made from grape-coloured taffeta, it is worn with a separate flesh-coloured boned bra, decorated with hanging tendrils of pearls and sequins that drip down over the dress.

Overleaf Single-breasted linen afternoon jacket with three-quarter length sleeves and "sleeping blue" velvet trim on the collar and pockets, circa 1940. Designed for daywear, the lavish embroidery of flowers and foliage in silk and metallic thread is used as decoration around the scalloped hem, sleeves and lapels. The two metal buttons are made from enamel and decorated with painted swans.

During the war years, when Schiaparelli was absent from Paris, the House at Place Vendôme had cautiously kept going, simply chugging along without fanfare or financial ruin. When finally the war ended and Madame Schiaparelli returned to her beloved Paris, she found familiar faces waiting to greet her. It was her intention to continue business where she left off, but times had changed. Materials were harder to get hold of, there was general unrest in the country and for the first time ever Schiap's instinct to provide simple dresses that were less constructed – in fact much softer and flatter with gently sloping shoulders – proved out of tune. A young Christian Dior had wowed Paris in 1947 with his New Look line and as Schiap said later, although the rusty wheels of her business were beginning to turn again, she soon "discovered the wheels no longer had their axles in the centre". When she attempted to revive the masculine look in August 1945, the frock coats were too reminiscent of those of German officers. Subsequent offerings of her Mummy silhouette, Dandy look and Hurricane line were also met with similarly lacklustre reviews. Future collections seemed too contrived and showy; nothing she attempted appeared to recapture the thrilling years of the 1920s and 1930s.

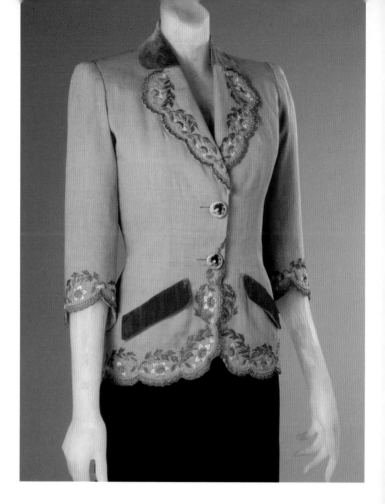

Opposite This lavishly embroidered dinner jacket in silk crepe was made for wearing in the evening and dates from 1940. Schiaparelli makes a feature of the two large pockets on the front, which are intricately decorated with gilded metallic thread by Lesage. She also uses distinctive embroidered gold buttons, as she hated plain round ones, and gold edging to define the collar and pocket flaps.

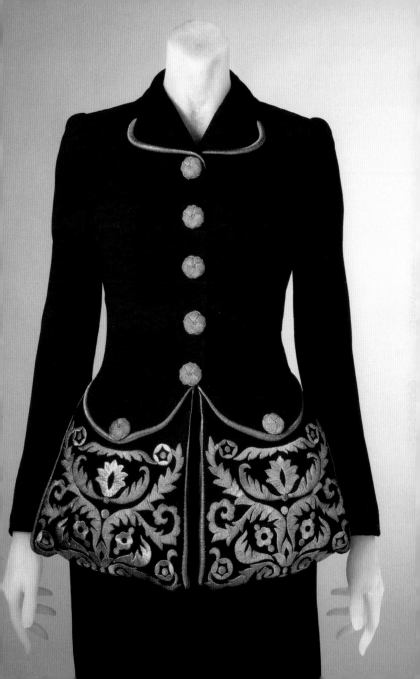

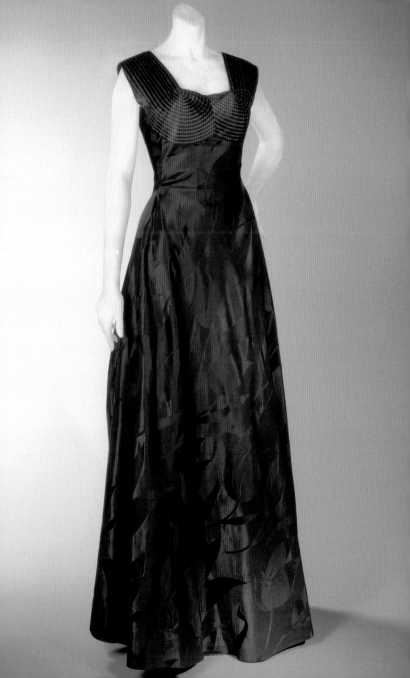

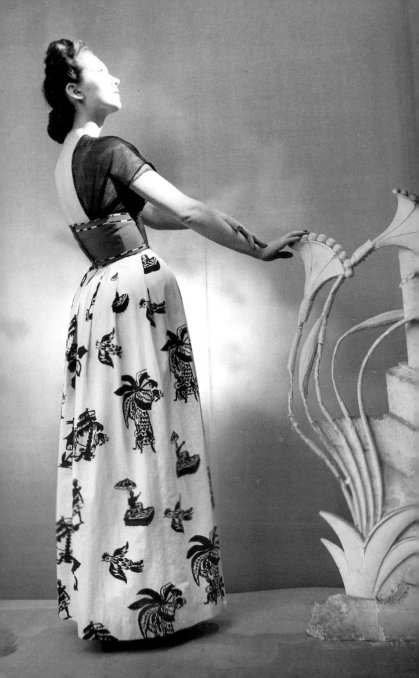

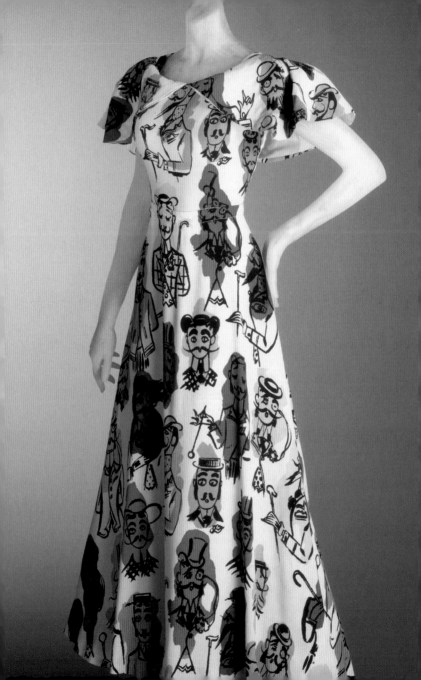

Schiaparelli showed her final collection in 1954. She accepted the closure of her business without bitterness and chose instead to spend her time with family and friends. Although she no longer designed clothes, she continued to have business interests, and travelled the world promoting her perfumes and accessories. Mostly though, she was happiest reading books and socializing with a loyal group of famous friends. Elsa divided her year between her two homes in Paris and Hammamet in Tunisia and spent much time with Gogo, her second husband Gino Cacciapuoti (an Italian, which thrilled Schiaparelli), and her two grandchildren Marisa and Berinthia. Schiaparelli died in her sleep at home in Paris on 13 November, 1973.

Shortly after her death, the company was sold to an American firm called Schiaparelli Inc, and during the 1980's and 1990's there were several unsuccessful attempts to relaunch the fashion house. In 2006 the company name and archive were acquired by Diego Della Valle, chief executive of Tod's group, with the intention of updating and reviving the Schiaparelli brand for a new generation.

Previous left Long evening dress of silk satin and rayon damask, circa 1948. This shimmery bronze gown has been printed with an intricate flower and foliage motif on a large scale, completely in contrast to the striped shoulder and breast panel. Spherical cutting and contrasting fabric is used to create the distinct breast cups that draw attention.

Previous right Evening dress from Paris, 1947. This dress is notable for its wide flat-boned cummerbund, championed by Schiaparelli as she tried out a variety of new silhouettes after the war.

Opposite The fabric print for this dress depicts fin-de-siècle gentlemen, with dandy moustaches. These cartoonish illustrations were all produced with the expertise of the silk printer Sache. The design from 1946 is called *Les Vieux Beaux* (The Old Beauties) and the dress features an unusually wide fluid collar that cuts over the shoulder to form a loose cap sleeve.

Overleaf Publicity still of Schiaparelli posing in the garden of her Paris home in August 1949. This photo was accompanied by a press release announcing her deal to manufacture coats and suits in New York.

This page Schiaparelli was one of the first designers to consider a total lifestyle for her customer. In addition to clothes and accessories, she turned her attention to lingerie. In the early 1950s she designed a range of quilted housecoats lined in shocking pink and also beautiful dressing gowns trimmed with extravagant mink and ermine collars. This mink-trimmed peignor dates from 1951.

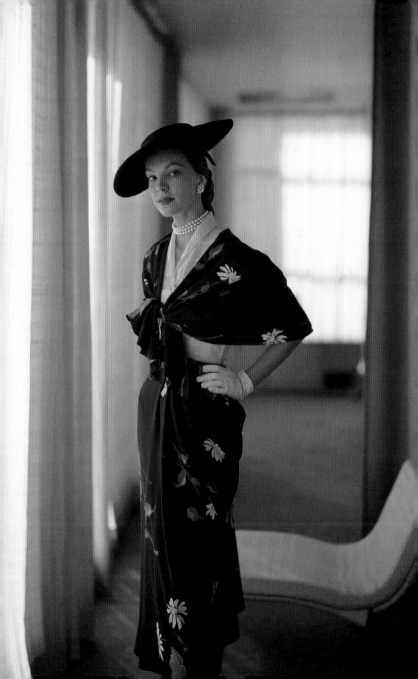

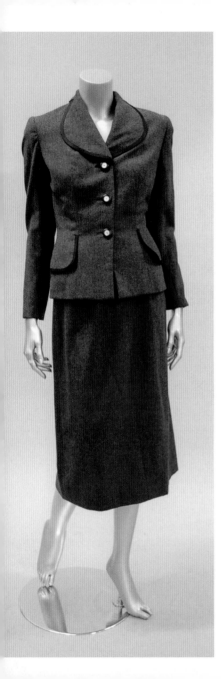

Previous left In 1950 Schiaparelli launched her Pyramid line of coats. This included the big duster coat, typical of which was this loosely sweeping and unstructured garment. The style usually came with three-quarter-length sleeves that often had turnback cuffs. Launched at the same time, the Dolman Greatcoat was much praised for the secret pockets hidden in the sleeves.

Previous right A model poses in a black floral summer two-piece, with mini cape that sweeps across the shoulder and ties in a deep V at the front, 1952. The matching hat and gloves are also by Schiaparelli.

Left An early 1950s damask-lined grey flannel suit with pencil skirt. The jacket has widely curved lapels, large flap pockets and mother-of-pearl buttons.

Opposite In 1954 at the age of 63, Schiaparelli showed her last collection. The theme was free and elegant and the collection, which was called Fluid line, showed shoulders that practically drooped. This raspberry pink raincoat with its oversize and strangely-cut collar was one of Schiaparelli's final designs.

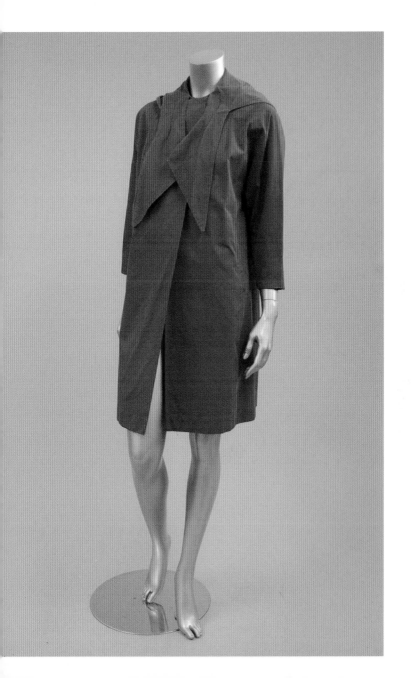

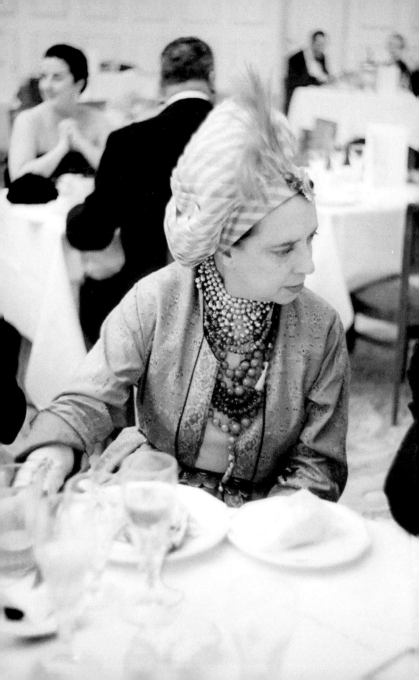

Accessories

From the beginning, accessories played an important role in Elsa Schiaparelli's collections as she preferred to design an entire ensemble, including shoes, hat, gloves and jewellery. By the 1930s, Schiap had built a reputation for creating daring and innovative accessories, but it was her hats that made the biggest impact, with such eccentric designs as the Lamb Cutlet Hat, the Brain-Hat and the Shoe-Hat. She used bold colours and unusual materials, often adapting everyday objects for her designs such as airplane propellers, igloos and even a birdcage holding a canary. Famous for her creative fashion sense and unorthodox free-thinking approach to detail and decoration, her designs were not merely unconventional, they were unworldly, such as a woven-grass brimmed hat decorated with crawling pink and green flies and beetles for her Pagan collection. Many of her millinery designs featured extravagant bouquets of flowers, brightly coloured feathers or heaps of fruit. She also introduced a Victorian revival in the form of the modern snood in 1935 and paved the way for a variety of turbans, pillbox and veiled styles with her radical designs.

Schiaparelli's early jewellery was showy, whimsical and surreal, with organic forms that seemed to owe their design more to the living form than the inanimate. There were aspirins strung together as necklaces and plastic beetles, bees and crickets. She was unique in her choice of materials, too, using china, porcelain, aluminium, glass, crystal and Plexiglas, as well as plastics.

Unfortunately, the licensing of her name to David Lisner coincided with a loss of that imaginative vision in design, and later pieces were

Opposite Elsa Schiaparelli taking tea in the mid-1950s in Paris. The turban was one of her favoured hat shapes because it was so versatile and it allowed her to keep reinventing the basic silhouette. Made from pink and ivory striped silk, with grosgrain ribbon and net, the stiffened headband provides sufficient rigidity to place decorative costume jewellery and a feather. This turban was donated to the Philadelphia Museum of Art.

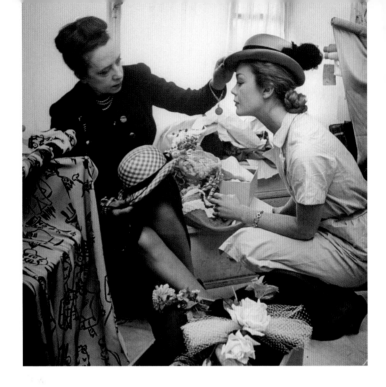

typical of the period, incorporating the popular "watermelon" glass and Aurora Borealis rhinestones. Her 1930s designs are unsigned and very rare until later in the decade, when her name appeared in lowercase block letters and then in script after 1949.

Schiap's collaborations with Italian shoemaker André Perugia, who worked in the same rue de la Paix building as she did, led to such designs as the Monkey-Fur boots (see page 43) and suede shoes with elastic fastenings that could be pulled on or off without the need for buckles, laces or buttons – a revolutionary idea at the time. In another "first" for the couturier, she and Perugia are credited with designing the wedge shoe with a cork heel.

Accessories provided Schiap with the perfect opportunity to show off both her imaginative vision and her practical side. Picking up details that others may have overlooked, she produced stockings with designs painted on the back of the legs and suede smoking gloves with a safety match tucked in the back that could be lit on the wristband.

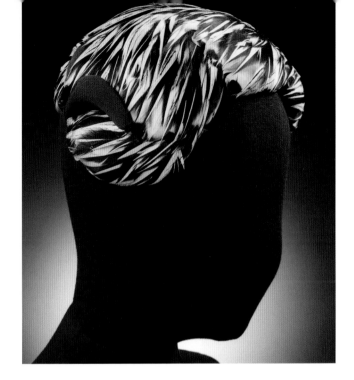

Opposite Schiap trying out hats on a model, circa 1951.

Overleaf left This black-and-pink wool felt Shoe-Hat from 1937 was perhaps her most whimsical design, inspired by a photograph of Dalí wearing his wife's slipper on his head. The shoe stands straight up, with the toe tilted over the wearer's forehead and the heel is in a shocking pink. This hat was worn by Singer sewing machine heiress and French *Vogue* editor Daisy Fellowes, among others.

Above The two main styles of hat during the 1950s were small skullcaps, suitable for a cocktail party or dinner, and wide "saucer" hats. This hat, designed by milliner Paulette Marchand (1900–84) for Schiaparelli, is constructed from intricately dyed game-bird feathers.

Overleaf right Schiaparelli, in Surrealistic mood, designed this red satin, visored evening cap with an elongated peephole for the eye. A diamond clip from Van Cleef & Arpels makes a unique eyebrow.

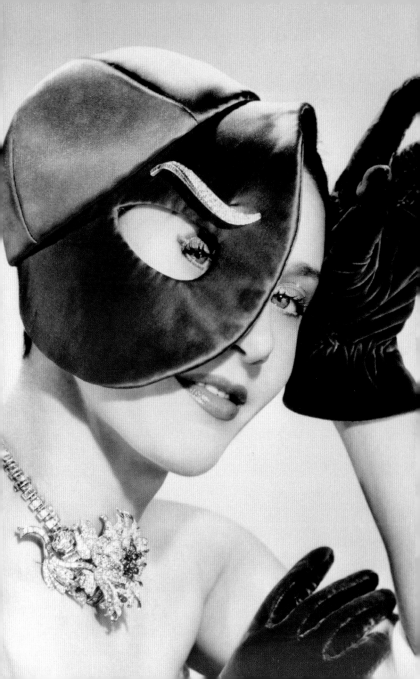

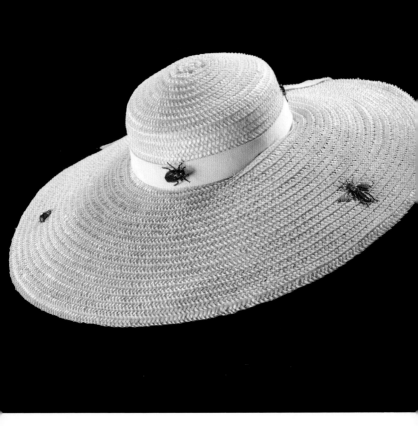

Above This hat, which was first
shown in autumn/winter 1938,
was part of Schiaparelli's Pagan
collection, which used nature and
the living world as its theme. Made
from woven grass, the large brim
was decorated with random bugs,
flies and insects.

Opposite A nest of kingfisher and
gull feathers appear perched on
top of a soft mink brim in this
extraordinary wool felt hat from
1938. Bird motifs often featured in
Schiaparelli's work; she produced
a birdcage hat and kept a birdcage
to display accessories at her shop.

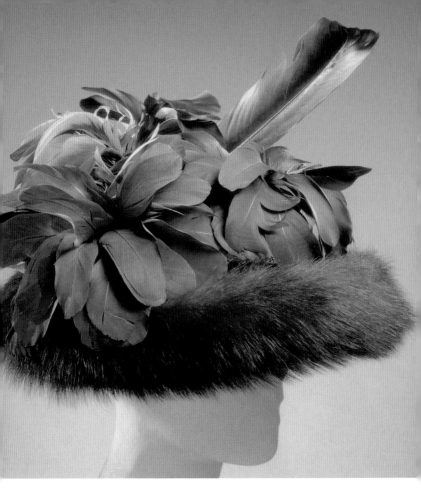

Overleaf left Portrait of Madame Schiaparelli by her friend and long-time collaborator, the Hungarian artist Marcel Vertès. Schiaparelli posed for *Harper's Bazaar* in 1938 in one of her new Oriental headdresses. The tiny pink fez sitting firmly on her crown was made from silk and decorated with embroidery, spangles and brightly coloured gemstones. Two silk scarves fell loosely from the fez to frame the face and wrap under the chin. Elsa's hand can be seen protruding from the scarf, adorned with multiple gold bracelets.

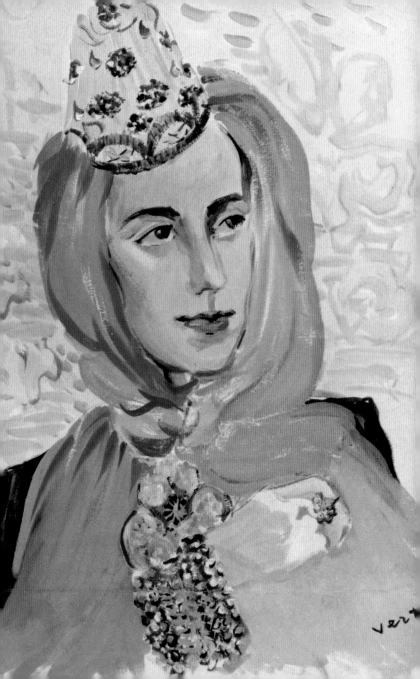

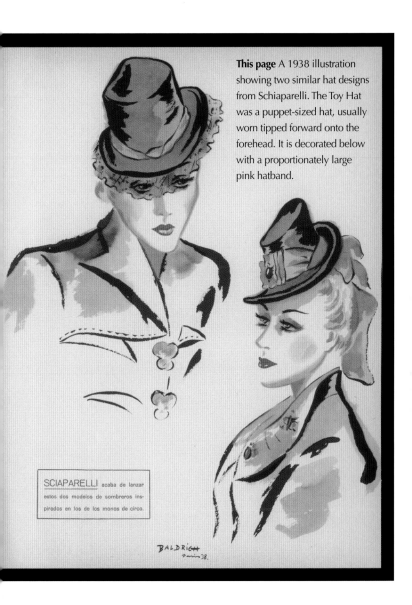

This page A 1938 illustration showing two similar hat designs from Schiaparelli. The Toy Hat was a puppet-sized hat, usually worn tipped forward onto the forehead. It is decorated below with a proportionately large pink hatband.

SCIAPARELLI acaba de lanzar estos dos modelos de sombreros inspirados en los de los monos de circo.

BALDRICH
Paris 38.

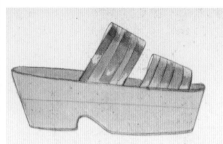

Striped kid straps on cork

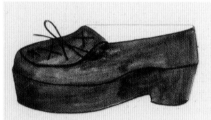

An elevated suede moccasin

Left, below and opposite

Schiaparelli always chose the best people to collaborate with when she needed to explore an area of expertise that she could not provide. Italian shoemaker André Perugia was one such person. Like the inventive couturier, Perugia was always experimenting and challenged preconceived notions of what a shoe should look like. For Schiaparelli he produced a shoe with a cork platform sole with striped kid straps (top left), a suede moccasin with a raised platform sole (centre) and two versions of a high-heeled satin sandal with kid-lined straps (below). He also designed summer shoes with a kinked ridged sole and thin ribbon laces that could be removed and re-tied as the customer wished (opposite).

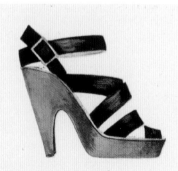

a high and mighty sole

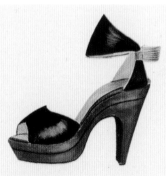

Satin lined with kid

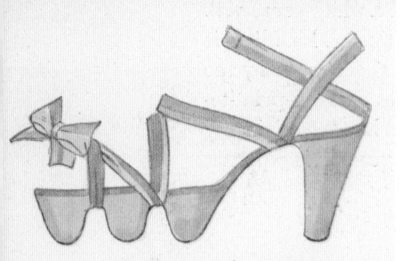

A kinked sole

Removable lacings

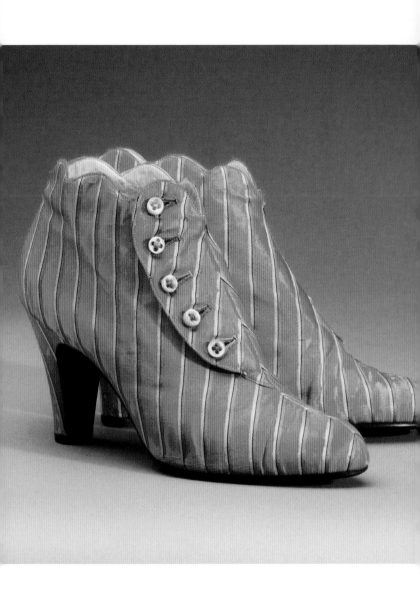

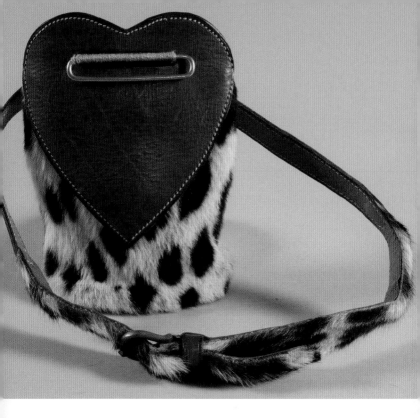

Opposite These silk satin ankle boots were also made by André Perugia for a specific collaboration with Schiaparelli in 1939–40. Made from leather and pink silk with a green and gold stripe, the flap opening is fastened with a row of tiny mother-of-pearl buttons.

Above The Duchess of Windsor was photographed wearing this ocelot fur pouch at Palm Beach in April 1950. It was on sale at the *Boutique des Ensembles Schiapsport* in 1949, and was made with a cylindrical base and a large leather heart-shaped panel, through which a metal loop was pushed to fasten it. The back of the pouch attaches to the fur-trimmed belt, which was fastened around the waist.

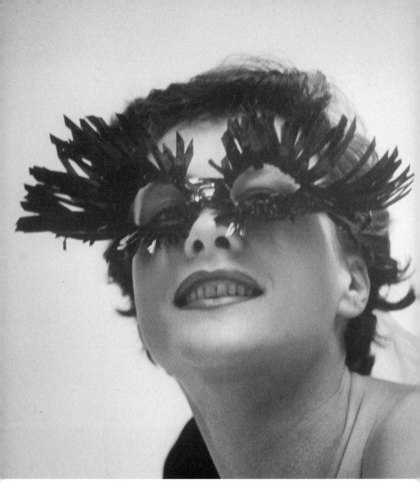

Above People expected Schiap to produce fantastical and amusing designs, and she rarely disappointed them. Her inventions were known as "Schiaparelli-isms", but not all were a huge success, like these sunglasses with fake eyelashes made from cellophane.

Opposite These black suede gloves with red snakeskin fingernails were made as accessories for the Surreal Desk suits, created in collaboration with Dalí in 1936. Schiaparelli produced two colourways: either in black or white, both with blood-red trim and nails.

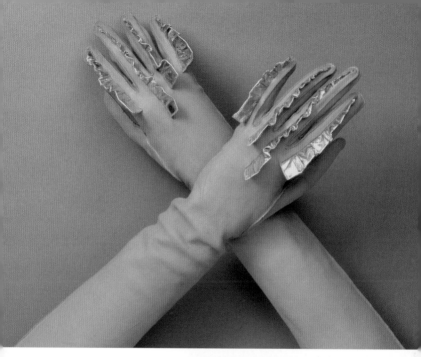

Above Touches of Surrealism were certainly evident on many of Schiaparelli's gloves. These elbow-length turquoise suede evening gloves from 1939 have gold kid ruffles running up the length of each finger, shaped in the form of the Italian *cornicello*, which is a small, gold, good luck charm used to protect the wearer from the evil-eye curse.

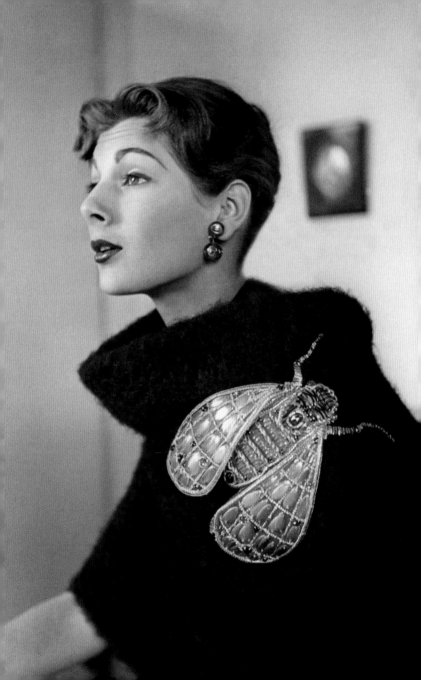

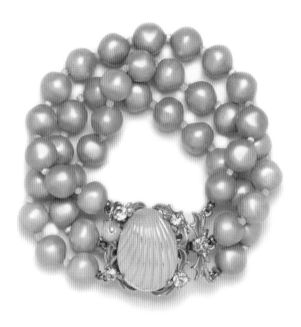

Opposite Schiaparelli often loved to distort the natural scale of things. Visually it shocked the senses to see a miniature hat or an oversize bow and here she created a super-size insect brooch, worn pinned to a black bouclé Shetland stole, 1952.

Overleaf A selection of ultra-modern bracelets and bangles from Schiaparelli, Boivin and Maggy Rouff from May 1935. The bold designs are graphic and architectural, from flat discs to chunky factory cogs.

Above At the beginning of her career Schiaparelli invented the name "junk jewellery" for her big ostentatious costume pieces, which she took care to position on the most severe clothes. Later she combined semiprecious stones with precious ones and started to work with Jean Schlumberger, who went on to become one of the world's most famous jewellers. This bracelet with three strings of coloured pearls, circa 1958, has a gilt metal clasp in the shape of a shell.

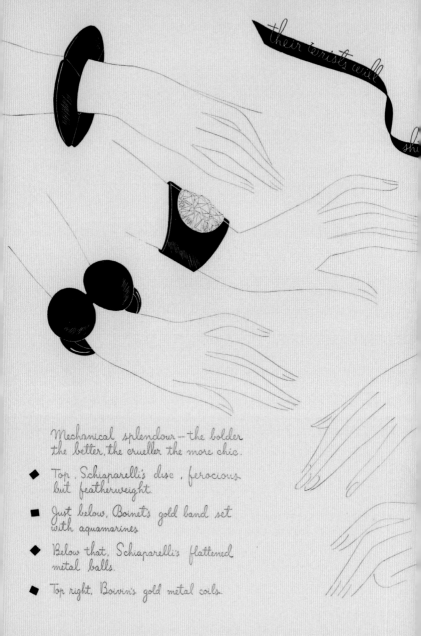

their wrists will

shi

Mechanical splendour — the bolder the better, the crueller the more chic.

◆ Top, Schiaparelli's disc, ferocious but featherweight.

■ Just below, Boivin's gold band set with aquamarines

◆ Below that, Schiaparelli's flattened metal balls.

■ Top right, Boivin's gold metal coils.

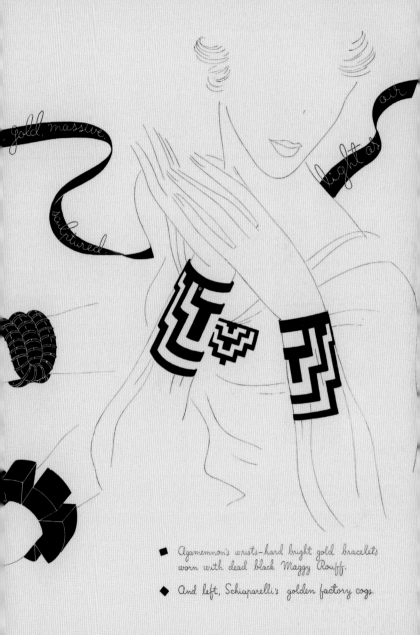

gold, massive

sculptured

light as air

● Agamemnon's wrists—hard bright gold bracelets worn with dead black Maggy Rouff.

◆ And left, Schiaparelli's golden factory cogs.

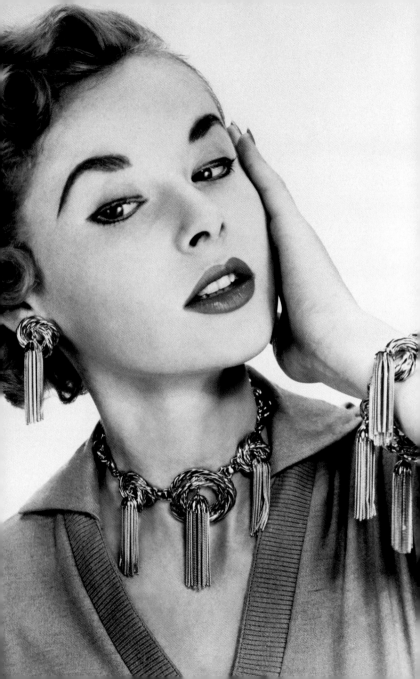

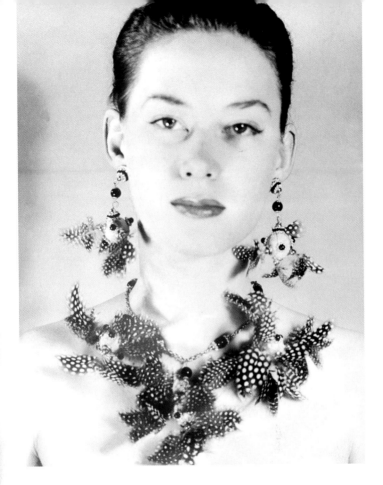

Opposite Tassels that swung around with the movement of the wearer were incorporated into a set of jewellery by Schiaparelli that comprised necklace, earrings and bracelet in 1953. The long streams of gold-coloured metal that fell from twisted swirling circles created a strong statement.

Above The tactile nature of bird feathers created jewellery that had a light textural quality but also moved easily when worn. This striking 1951 necklace was made from guinea fowl feathers that were mounted in clusters onto bright yellow taffeta balls, with matching dangling earrings.

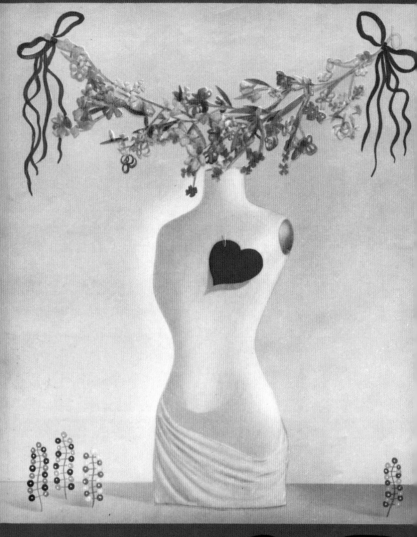

Shocking
de
Schiaparelli

Fragrances by Schiaparelli

Elsa Schiaparelli was not the first couturier to expand into the perfume market, as her great mentor Paul Poiret had, as early as 1911, established a fledgling market for designer perfume, followed by Patou and Chanel in the 1920s. It was 1928 by the time Schiaparelli invaded the market with the first of many products, which over the course of her career were to become extraordinarily successful and as she said, "proved to be her salvation when hard times came". Crazily superstitious, Schiaparelli had decided that all her perfumes needed a name that started with the letter S, a small vanity perhaps that must have seemed easy to accommodate at the launch of *Salut* in 1934 and *Soucis* and *Schiap*, which quickly followed, but became increasingly harder to continue as new fragrances were produced over a period of 20 years. Without consultation, it was the voluptuously sexy body of

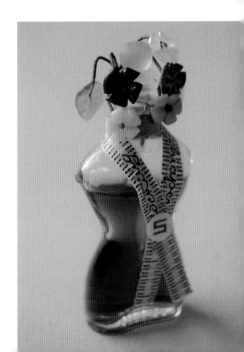

Opposite A 1930s advertisement for *Shocking* perfume. The top notes are aldehydes, bergamot and tarragon; middle notes are honey, rose and jasmine; base notes are cloves and civet.

Right An oriental floral fragrance for women, *Shocking* by Schiaparelli was launched in 1937. The bottle design, based on the figure of Hollywood star Mae West, was adopted by Jean Paul Gaultier for his fragrance for women in 1993.

the movie star Mae West that provided the inspiration for Schiaparelli's most famous perfume, *Shocking*. Having previously measured the actress's body in preparation for costume fittings, Schiaparelli recalls, "She had sent me all the most intimate details of her famous figure, and for greater accuracy a plaster cast statue of herself quite naked in the pose of the Venus de Milo."

The naked woman's torso, which exemplified a perfect hourglass figure, remained in the studio and eventually became the inspiration for the *Shocking* perfume that came in a nakedly curvaceous body-shaped bottle. The young Italian Surrealist artist Leonor Fini designed the bottle, copying the actress's celebrated curves, but exaggerating broad Schiaparelli-type shoulders and an impossibly slim waist. A tape measure was draped around the neck, pulled together at the bosom to form a deep V-neck, and fastened with a mini button "S".

The perfume was launched with an explosion of shocking pink and, without any advertising campaign, it became an immediate bestseller. In 1938, *Sleeping* was launched in a hugely extravagant Baccarat crystal candlestick bottle, with a red glass lighted taper and a cone-shaped extinguisher to put over the top. Clever, witty, beautifully presented in strong turquoise and gold packaging, Schiaparelli's attention to detail never waned and she always found the best in the business to translate her visual ideas into commercial reality.

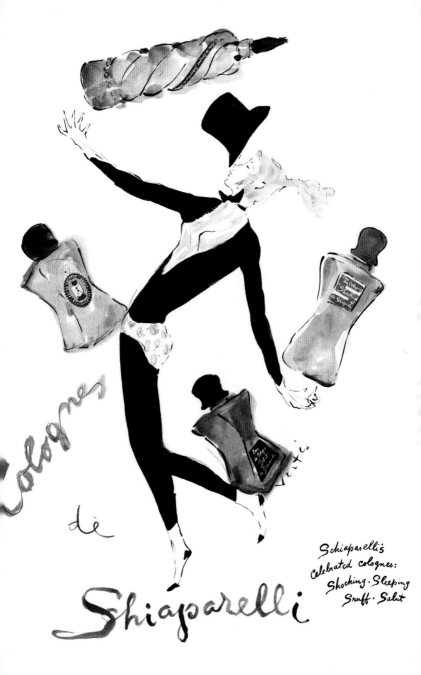

colognes

de

Shiaparelli

Schiaparelli's
Celebrated colognes:
Shocking · Sleeping
Snuff · Salut

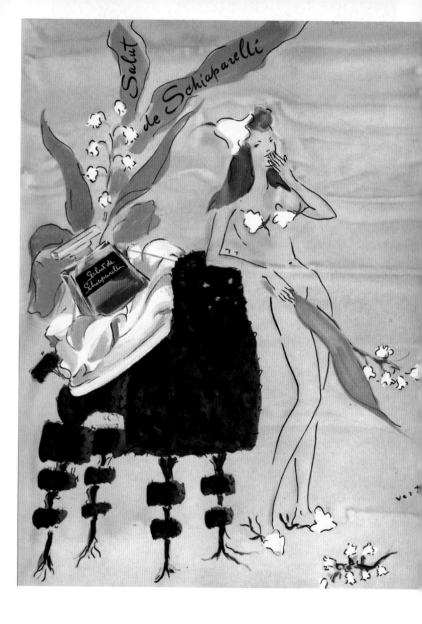

Salut de Schiaparelli

Fragrances by Schiaparelli

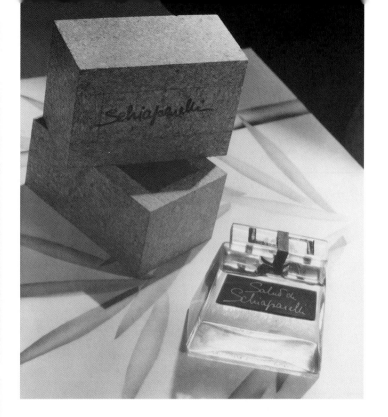

Opposite and above Schiaparelli was one of the first couturiers to invade the perfume market and in the early 1930s she created three fragrances that were produced in England. *Salut* was put on sale in 1934; it was a light evening fragrance that hinted at lily-of-the-valley. The magazine illustration (opposite) shows an advert for *Salut de Schiaparelli* from the 1940s by Marcel Vertès, who was commissioned to produce nearly all the advertising imagery for Schiaparelli's perfumes. The unusual box (above), in which the perfume was presented, was made in cork by Jean-Michel Frank, an interior designer employed by Schiaparelli to decorate her shops and also her own apartment.

Opposite Faithful to her links with the Surrealists, and their obsession with dreams, *Sleeping* was meant to be a night-perfume to be spritzed before falling into bed. The scent was designed to "illuminate the subconscious and light the way to ecstasy," according to this ad, illustrated by Marcel Vertès. The turquoise blue of the packaging was also a new colour for Schiaparelli and was described as "sleeping blue".

Above The bottle for *Sleeping* depicted a candleholder with a red flame. It came in a box designed as a cone-shaped extinguisher.

Sleeping
de
Schiaparelli

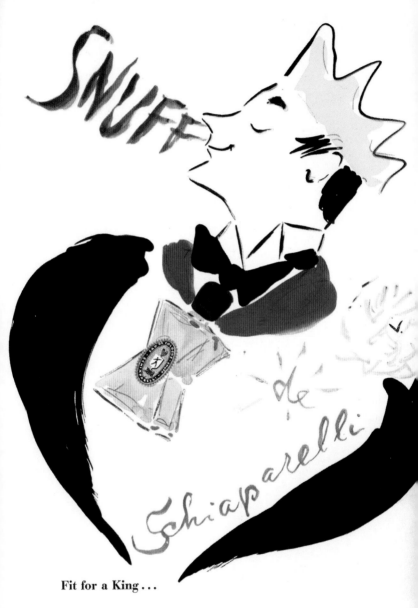

Fit for a King...

a hundred-and-ten-percent he-man cologne for father...9.00 and 5.00 *prices*

also perfume, lotion, talc, soap, shave cream

Paying homage to René Magritte's famous Surreal painting *Use of Words* 1 (1929), which features a straightforward representation of an man's pipe with the words "*Ceci n'est pas un pipe*" written underneath, Schiaparelli launched a perfume for men called *Snuff* in 1939. Presented in a small cardboard box designed as a cigar box that opened to reveal a bed of straw and a man's crystal glass pipe filled with a dry, sober scent, the concept of a fragrance designed exclusively for the male market was yet another Schiaparelli first. The range continued with a collaboration with Dalí, who designed the elaborate bottle for *Le Roy Soleil*, based on a large golden clam shell that opened up to reveal the perfume inside.

Schiaparelli's imaginative series continued with many other perfumes, including *Succès Fou*, *Si*, *S* and *Zut*, which came in a bottle designed to complement the erotic *Shocking* torso, shaped instead to suggest the curvy lower half of a woman's body.

Opposite Marcel Vertès produced sketches for all the different products Schiaparelli needed to advertise, as she thought his spontaneous fresh style of illustration perfectly encapsulated her brands. This was a 1950s advertisement for *Snuff*, designed for the British market.

Below *Snuff* was launched in 1939, the first perfume designed exclusively for the male market. The bottle was shaped to form a man's smoking pipe, and it came beautifully wrapped up in a cigar box. The chypre scent was visible in the shaft of a crystal-glass pipe and the stopper was cork.

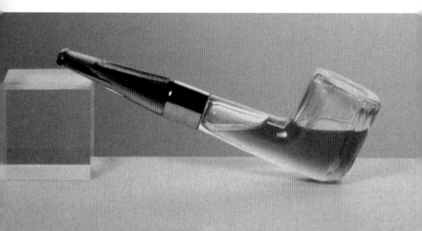

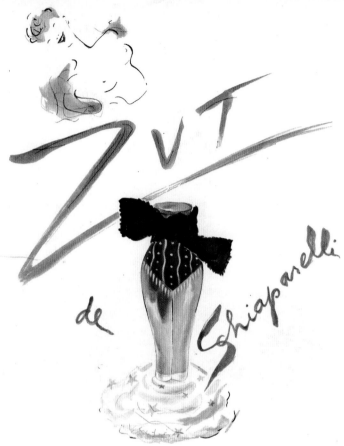

Schiaparelli's new perfume sensation ...100% imported from France

Above The perfume *Zut* was launched in 1949 and the bottle designed to complement the naked torso Schiaparelli had used years earlier for *Shocking*. It showed a woman's lower body standing immersed in a fluffy white cloud with stars.

Opposite The elaborate bottle for *Le Roy Soleil* was designed by Dalí in 1946. The sweet jasmine-smelling scent came in a bottle that represented the Sun King's face, presiding over a wavy blue sea with birds and fishes. Vertès produced the witty illustration.

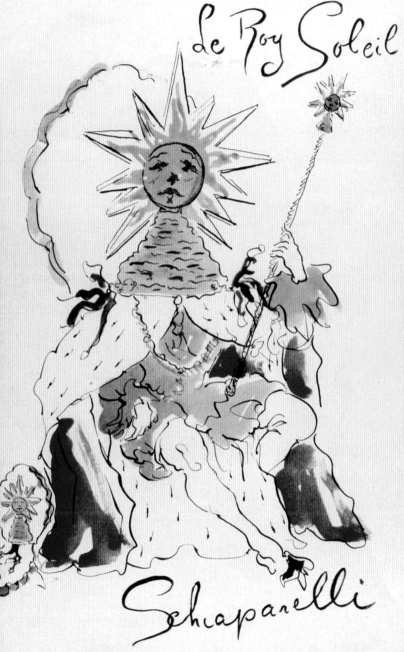

Le Roy Soleil

Schiaparelli

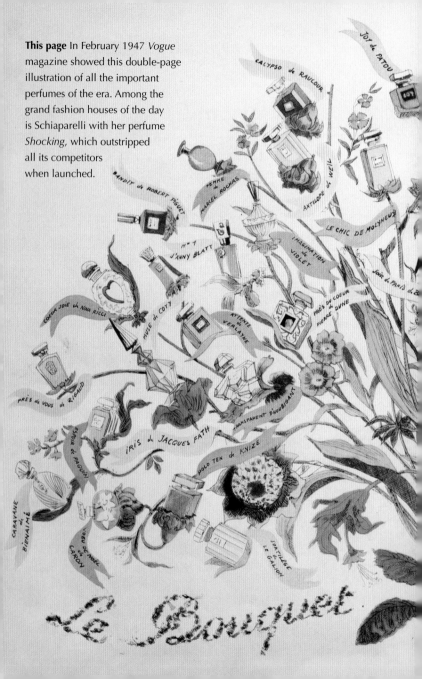

This page In February 1947 *Vogue* magazine showed this double-page illustration of all the important perfumes of the era. Among the grand fashion houses of the day is Schiaparelli with her perfume *Shocking*, which outstripped all its competitors when launched.

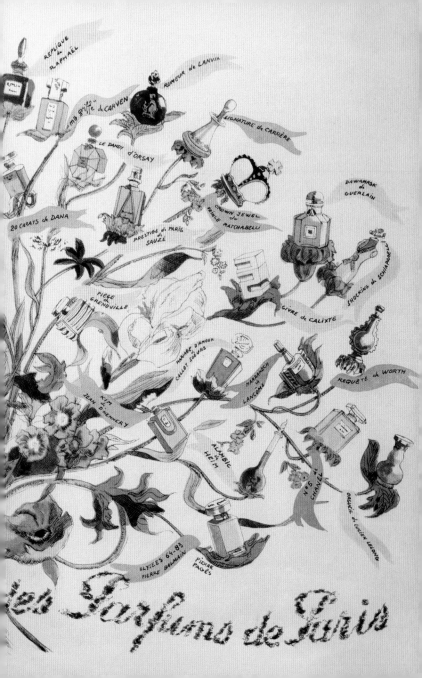

A Revival for the Twenty-First Century

An exhibition held at New York's Costume Institute of The Metropolitan Museum of Art in 2012 did much to boost the fading reputation of Schiaparelli, highlighting the forgotten genius of a woman who was, after all, one of the most famous couturières in Paris between the 1920s and '50s. *Schiaparelli and Prada: Impossible Conversations* examined the work of two iconic Italian fashion designers, looking at the similarities and disparities of both women's creative output, how they engaged with contemporary artists, embraced the paradoxes of fashion and challenged the concept of beauty by popularizing "ugly" aesthetics. Showcasing Schiaparelli's unique modernity, with exhibits that included her surreal Shoe-Hat, black crêpe Skeleton Dress with padded ribs and spine, severe tailoring and exquisite use of embroidery, the successful exhibition reinforced her influence within contemporary fashion and reminded the public of her innovative embrace of Surrealist humour.

Opposite Blazing down the catwalk for Bertrand Guyon's collection for Autumn/Winter 2018, this Schiaparelli pink gown symbolizes the mix of tradition and innovation that has come to characterize the house's revival.

Overleaf left The Schiaparelli and Prada exhibition at New York's Metropolitan Museum of Art in 2012 reminded everyone that Schiaparelli, though a champion of colour, was not afraid to use black, as seen here in her suits from the late 1930s.

Overleaf right Outfits from the famous Circus collection from 1938 were on display at the Schiaparelli and Prada exhibition. Free-form, childlike drawings enliven a silk crepe evening gown with matching cape, with dancing horses and acrobat buttons used as detailing on the silk twill jacket.

In tribute to Elsa, the French couturier Christian Lacroix was asked to design a one-off haute couture collection for the House of Schiaparelli to honour the woman who had been so important in shaping his own career. Known throughout the late 1980s and 1990s for his exceptional use of clashing colour and his signature inclusion of giant oversized bows, Lacroix was a perfect choice to create a stunning, 18-piece collection in homage to the woman who had regularly shocked the world with her outlandish ideas. In July 2013 during the Paris couture presentations, Lacroix revealed his spectacular pieces (not for sale), shown on mannequins on a revolving carousel, in the magnificent setting of the Pavillon de Flore, part of the Palais du Louvre. Guests arrived through a recreated version of the bamboo cage that Jean-Michel Frank had originally designed for Schiaparelli's atelier, with electronic birdsong projected through a canopy of foliage and flowers. Not wanting simply to re-present the trademarks of Lobster print and Shoe-Hat for which Schiaparelli had become so famous, Lacroix looked elsewhere for inspiration, choosing instead to reference her flamboyant use of colour, love of circus motifs and exaggerated silhouettes. Lavish embroidery, oversized pockets, conical Pierrot pom-pom hats and clever juxtaposition of colour were evident in Lacroix's modern take on Schiaparelli, all of which served as a brand teaser, helping to raise the profile of the house in preparation for the appointment of a new design director later that year.

Opposite This spectacular evening dress in bold pink and black stripes, made from duchess satin, evokes the daring spirit of Schiaparelli at her best. It was designed by Christian Lacroix, with eye-catching details of rosette corsage and voluminous bustle.

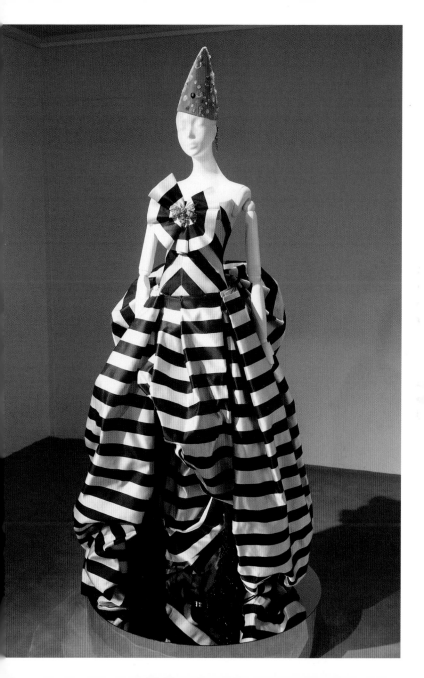

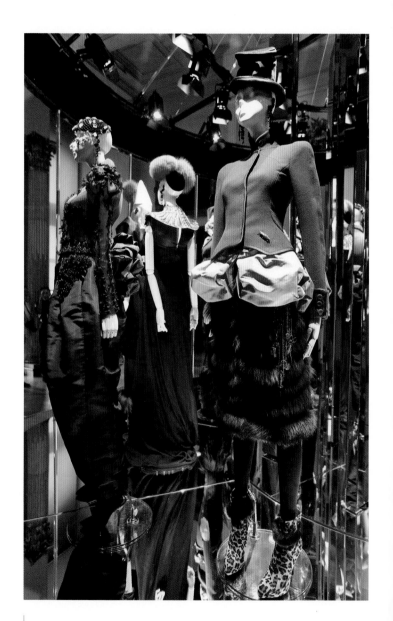

Italian designer Marco Zanini was announced in October 2013 as the creative director of Schiaparelli, and clearly understood the significance of the complex challenge he was undertaking. While adhering to the spirit of Schiaparelli, he needed to create brand awareness for a name that was revered within the fashion world but which lacked the global profile of others in the luxury market. The challenge to ignite a label that had been dormant for so many years was a privilege, he told *Vogue*'s Lynn Yaeger, but also felt like "a total start up". His wildly creative imagination would be applauded, but Zanini was criticized for designs that played too literally in reflecting Schiaparelli's oeuvre and were considered unwearable, and his tenure was short-lived. Thirteen months later, the house announced the end of its collaboration with the designer.

They had already lined up a replacement, named the following year as Bertrand Guyon, an experienced fashion creative who had previously worked at Givenchy, Lacroix and Valentino. Guyon joined as design director at Schiaparelli in April 2015 and was credited with making the brand more accessible while still retaining elements of the daring innovation that was the trademarks of its founder. He launched the ready-to-wear line, was adept at reimagining the signatures of the house such as trompe l'oeil shadows and sunburst iconography, and steadily built up a significant celebrity fanbase. Guyon re-established a strong identity for the couture house, with intelligent collections that appealed to the fashion sensibilities of actors like Tilda Swinton and Cate Blanchett, who were happy to wear Schiaparelli on the red carpet.

Opposite Mannequins shown on a revolving carousel, wearing Christian Lacroix's unique collection designed to honour Schiaparelli, were presented in Paris during the couture collections in 2013.

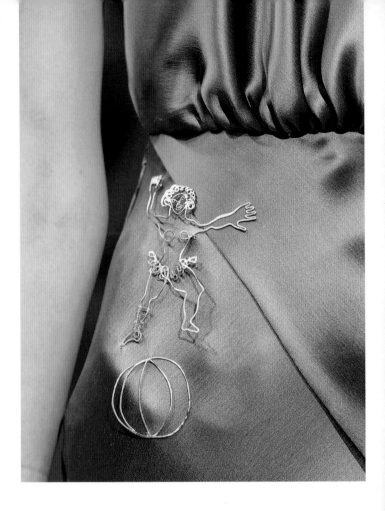

Above This detail on a satin evening gown references Schiaparelli's acclaimed Circus collection from 1938, reinterpreted for the 2016 haute couture Autumn/Winter show.

Opposite This updated reinvention, in the form of an exaggerated shoulder line, leopard skin prints and pannier-like pockets, appeared on the catwalk for Bertrand Guyon's collection for Autumn/Winter 2018.

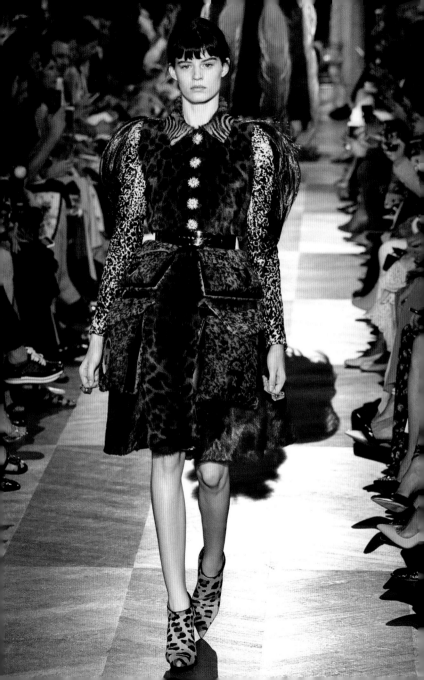

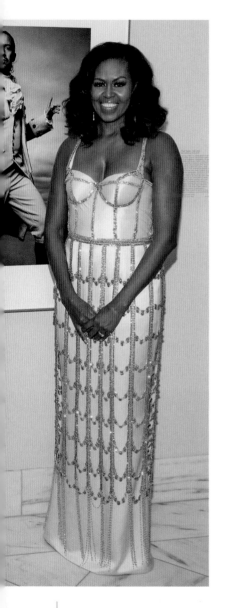

Left Designed by Daniel Roseberry to reflect her "strength and honour", Michelle Obama appeared in this acid yellow, haute couture gown at the American Portrait Gala. The statement dress, with fitted bodice and sweetheart neckline, is decorated with crystal bead overlay.

Opposite Appearing at the Venice Film Festival in 2018, Tilda Swinton chose a bias-cut gown with bold leopard-print type pattern, from the Autumn/Winter haute couture collection. Surreal, glove-like detailing on the sleeves and matching shoes completes the look.

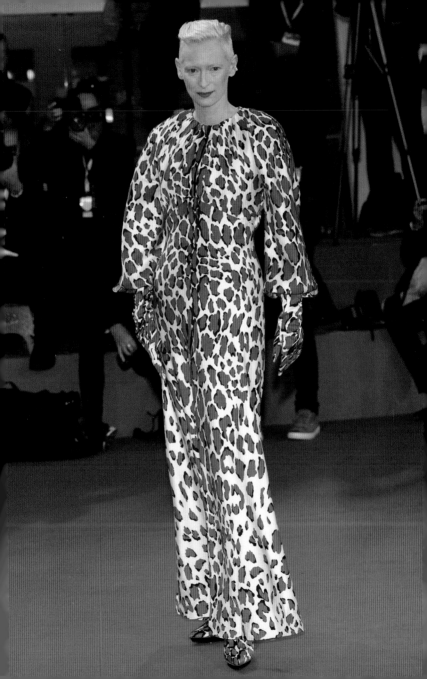

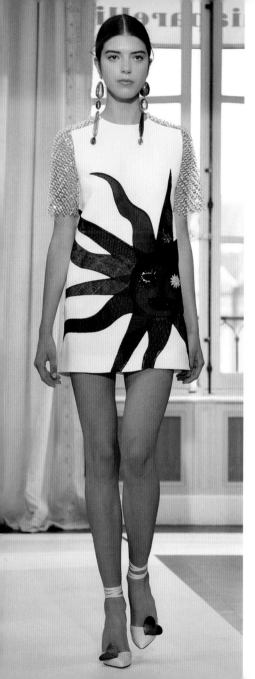

Left Sunburst iconography, a recognized trope of the house, was made famous in Schiaparelli's Zodiac collection from 1938. It is referenced in a strikingly modern way for a new generation of fans in 2017.

So a statement issued by Schiaparelli, thanking Guyon "for his contribution to the haute couture activity of the House", surprised everyone when it was released in April 2019. A week later the company announced Daniel Roseberry as his successor, responsible for all collections and projects at the prestigious headquarters at the Place Vendôme. Having previously spent over a decade working for Thom Browne in Manhattan, the 33-year-old, Texan-born designer was the first American to head up an established French couture house. His debut collection came just two months later, where he showcased his vision for the brand, determined to focus on a modern take of Schiaparelli's individual spirit of irreverence and innovation, rather than get too heavily mired in the mythology of her iconography.

His assured start showcased a multitude of fantasy ideas, manipulated fabrics and prints, and utilized embroidery, feathers and gemstones in a collection that was notable for statement jewellery, exquisite tailoring and gravity-defying touches of artistic genius. It laid a bold foundation for what was to come and was heralded a great success by the fashion press. Speaking to Tim Blanks in September 2020, Roseberry explained his mission for the house was to "honour and embody Elsa Schiaparelli's ethos", insisting that to simply replicate what she did "would be a very arrogant disaster". Sketching original ideas on paper, then transferring them to a computer to construct an analogue digital collage, creates a modern chemistry for Roseberry, who feels this is a way to enrich his design process. Every stage of his creative procedure is beautifully documented on the official website and his Instagram postings, a conscious decision to enable his customers and fans to engage with his vision.

His ambition to push the Schiaparelli boundaries, and allow the world to feel part of his exciting journey to turn the house into one of the most influential of the twenty-first century, is well under way.

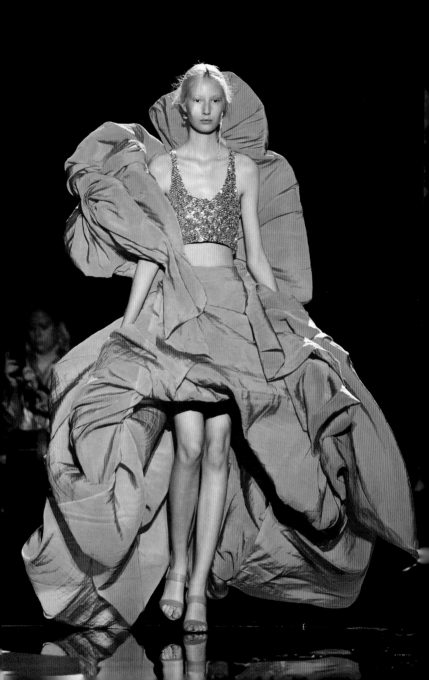

Opposite Excessive volume was showcased in the finale of Daniel Roseberry's debut show for Schiaparelli in 2020, in the form of this surreal, gravity-defying, rose pink, taffeta evening dress.

Above Lady Gaga in haute couture at Joe Biden's inauguration ceremony in January 2021. Her cashmere collarless jacket, designed to keep her vocal cords free, was decorated with a large gold dove holding an olive branch.

Index

Page numbers in *italic* refer to illustration captions.

Resources

Further Reading

Baudot, François, *Elsa Schiaparelli: Fashion Memoir*, Thames and Hudson, 1997

Baudot, François, *Fashion and Surrealism*, Assouline Publishing, 2001

Blum, Dilys E, *Shocking! The Art and Fashion of Elsa Schiaparelli*, Yale University Press, 2003

Laubner, Ellie, *Collectible Fashion of the Turbulent Thirties*, Schiffer Publishing, 1999

Mackrell, Alice, *Art and Fashion*, Batsford Ltd, 2005

Martin, John, *Fashion and Surrealism*, Thames and Hudson, 1989

Schiaparelli, Elsa, *Shocking Life The Autobiography of Elsa Schiaparelli*, V&A Publications, 2007

White, Palmer, *Elsa Schiaparelli: Empress of Paris Fashion*, Aurum Press, 1986

Collections

Due to the fragility and sensitivity to light, many fashion collections are rotating or on view through special exhibition only. Please see the individual websites for further information.

Phoenix Art Museum
Arizona Costume Institute
McDowell Road and Central Avenue
1625 North Central Avenue
Phoenix, AZ 85004, USA
www.arizonacostumeinstitute.com

The Metropolitan Museum of Art
The Costume Institute
1000 Fifth Avenue
New York, New York 10028-0198, USA
www.metmuseum.org
Many items are part of the the Brooklyn Museum Costume Collection (www.brooklynmuseum.org).

Philadelphia Museum of Art
Costume and Textiles Collection
Main Building
26th Street and the Benjamin Franklin Parkway
Philadelphia, PA 19130, USA
www.philamuseum.org

The Victoria & Albert Museum
Fashion: Level 1
Cromwell Road
London SW7 2RL, UK
www.vam.ac.uk

Acknowledgements

Picture Credits

The publishers would like to thank the following sources for their kind permission to reproduce the pictures in this book.

Key: t=Top, b=Bottom, c=Centre, l=Left and r=Right

Akg Images: /Archives CDA/Guillot: 144
Image Courtesy of The Advertising Archives: 138, 141, 142, 145, 146, 148
Bridgeman Images: /Kunstmuseum, Basel, Switzerland /© Salvador Dalí, Fundació Gala-Salvador Dalí, DACS, 2011: 81, /Philadelphia Museum of Art, Pennsylvania, PA, USA /Gift of Mme Elsa Schiaparelli, 1969: 20, 42, 43, 47, 49, 52, 56, 61, 63, 67, 68, 83, 104, 105, 106, 108, 123, 128, 131t, 131b, /Philadelphia Museum of Art, Pennsylvania, PA, USA /Gift of Mrs Rodolphe Meyer de Schauensee: 64, /Private Collection /Archives Charmet: 150–151, /Private Collection /Photo © Christie's Images /© Man Ray Trust/ADAGP, Paris and DACS, London 2011: 86
 Getty Images: 92, 96, /Bettmann: 3, 26, 88, 110, 121, /Stephane Cardinale - Corbis/Corbis via Getty Images 152, 160, 163, 164, 166, /Condé Nast Archive: 6, 18, 29, 36, 38–39, 80, 93, 94, 95, 98, 132, 143, /Julio Donoso/Sygma: 58, /Jonathan Ernst-Pool 167; /Gamma-Keystone: 10, /Francois Guillot/AFP 158, /Julien Hekimian 157, /Hulton Archive: 8, 12, 100, /Genevieve Naylor: 16, 101, 112, 113, /Philadelphia Museum of Art: 74, 75, 78, 85, 87, /Simon Russell 155, /Underwood & Underwood: 23, /Roger Viollet 30, 107, /Peter White 161, /Paul Zimmerman/WireImage 154, /Time & Life Pictures: 50, 102, 111, 118, 130
Kerry Taylor Auctions: 114, 115, 129
Mary Evans Picture Library: 125, /National Magazines: 1, 2, 4, 24, 25, 28, 35, 53br, 53tr, 53bl, 65, 84, 120, 124, 126–127, 134–135, /Retrograph Collection: 149
Collection of Phoenix Art Museum, Gift of Mrs John Hammond. Photo by Ken Howie: 40l & 40r
Picture Desk/The Kobal Collection: /Paramount: 91
Shutterstock: /GTV Archive: 97, /Paul Morigi/Invision/AP 162

SuperStock: /© Salvador Dalí, Fundació Gala-Salvador Dalí, DACS, 2011: 76–77
Topfoto.co.uk: 137, 147, /L. Degrâces et P. Ladet /Galliera /Roger-Viollet:
31, 69,
Ronald Grant Archive: 90, /ullstein bild: 21, /Roger Viollet: 14, 37, 72, 116
Victoria & Albert Museum/V&A Images – All rights Reserved: 33, 34, 42,
45, 46, 54, 55, 57, 59, 60, 62l, 62r, 66, 70, 79l, 79r, 82, 119, 122, 133,
160, 176

Author Acknowledgements

Thanks go to the superb collections from the Victoria & Albert
Museum, the Philadelphia Museum of Art, the Metropolitan
Museum of Art, the Arizona Costume Institute at the Phoenix
Art Museum and Kerry Taylor Auctions. Special thanks to my
fabulous editor Lisa Dyer and all the team at Carlton Books.

Overleaf Detail of the embroidery
on a plum silk velvet jacket that
was made as part of a suit in 1937.
Lesage produced the exquisite
work with silk and metallic threads,
rhinestones and tiny sequins. The
bright pink floret-shaped buttons
are functional as well as decorative
and are made from metal.